PICTURING IRAN

ART, SOCIETY AND REVOLUTION

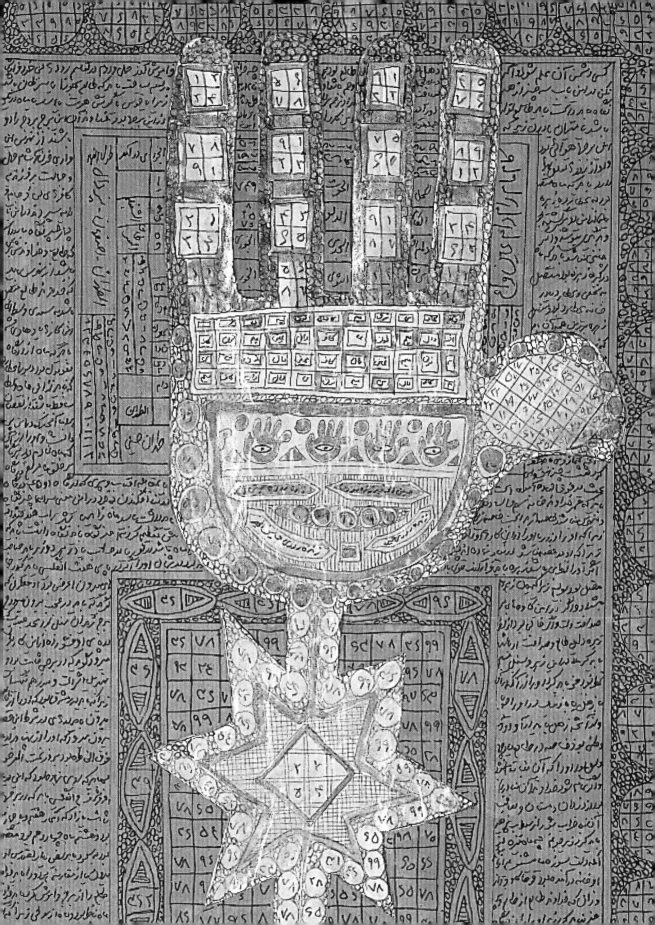

PICTURING IRAN

ART, SOCIETY AND REVOLUTION

Edited by Shiva Balaghi and Lynn Gumpert

I.B. TAURIS

LONDON · NEW YORK

Published in 2002 by I.B.Tauris & Co Ltd.
6 Salem Road, London W2 4BU
175 Fifth Avenue, New York NY 10010

In the United States and in Canada distributed by Palgrave Macmillan, a
division of St. Martin's Press
175 Fifth Avenue, New York NY 10010

This volume accompanies the exhibition "Between Word and Image: Modern
Iranian Visual Culture," organized by the Grey Art Gallery and the Hagop
Kevorkian Center for Near Eastern Studies at New York University.

Grey Art Gallery, New York University, September 18-December 7, 2002.

Picturing Iran: Art, Society and Revolution and "Between Word and Image:
Modern Iranian Visual Culture" have been made possible, in part, by the
Rockefeller Foundation, the Reed Foundation, the Soudavar Memorial
Foundation, the Iran Heritage Foundation, and the Flora Family Foundation.
This project also received funding from New York University's Offices of the
Provost, Academic and Health Affairs, and Student Affairs; the Hagop
Kevorkian Center's grants from the U.S. Department of Education and the
Ford Foundation's Crossing Borders programs; and from the Grey Art
Gallery's Abby Weed Grey Trust.

This publication was prepared by the Grey Art Gallery and the Hagop
Kevorkian Center for Near Eastern Studies at New York University.

Grey Art Gallery, New York University
100 Washington Square East, New York NY 10003

Hagop Kevorkian Center for Near Eastern Studies, New York University
50 Washington Square South, New York NY 10012

ISBN: 1 86064 883 5

A full CIP record for this book is available from the British Library
A full CIP record for this book is available from the Library of Congress

Library of Congress catalog card: available

Designed and typeset by Karen Stafford, London
Printed and bound by the Bath Press, CPI Group UK

COVER ILLUSTRATIONS:
(FRONT) HOSSEIN ZENDEROUDI. *The
Sun and the Lion*. 1960. Detail of Fig. 11;
(BACK AND SPINE) MORTEZA MOMAYEZ.
Poster depicting fists as tulips.
c. 1978–79. Fig. 8

CONTENTS

NOTE ON TRANSLITERATION

The transliteration system in this volume is a modified version of the style used by the journal *Iranian Studies*. Our system was derived with an emphasis on helping non-specialists pronounce the Persian words properly. It also minimizes the use of diacritical notations and retains popular American spellings of words like Koran.

ACKNOWLEDGMENTS

Picturing Iran: Art, Society and Revolution resulted from our collaboration on an exhibition entitled "Between Word and Image: Modern Iranian Visual Culture," mounted at the Grey Art Gallery, New York University's fine arts museum, in 2002. The Grey's permanent collection includes over 200 works of modern Iranian art—an extremely important holding and an understudied resource. Rather than mounting a comprehensive survey, however, we decided to address questions about modernity in Iran through the lens of visual culture. We focused on three discrete but interrelated aspects: fine arts; graphic arts, in the form of revolutionary posters; and black-and-white photography—in this case, works by Abbas, a prominent Iranian photojournalist living in Paris. Surrounded by knowledgeable and expert colleagues, we came to realize that this collection of original essays was not only possible but essential. The origins of this ambitious undertaking date back to more than four years ago, when Peter Chelkowski and Robert Dannin, who both teach at NYU, met with the staff of the university's Hagop Kevorkian Center for Near Eastern Studies to propose an exhibition of Abbas's photographs. They, in turn, approached the Grey Art Gallery. During the following months of research and discussion, the outline of the exhibition and this collection of essays was developed.

Since the earliest planning stages, Abbas has been extraordinarily generous in sharing his work, time, and insights. The contributors to this volume, too, have been instrumental in helping to organize the 2002 exhibition. Fereshteh Daftari has been a tireless collaborator and worked as a co-curator on the show, and we also gratefully acknowledge Haggai Ram's advice in selecting the posters. Peter Chelkowski's pioneering study of modern Iranian graphics opened up this area for further study. He and Timothy Mitchell,

Director of the Kevorkian Center, were essential to the realization of this complex interdepartmental undertaking. We have also benefited greatly from the encouragement and support of several NYU faculty members, in particular Farhad Kazemi, Priscilla Soucek, Michael Gilsenan, and Zachary Lockman.

Other colleagues have likewise been immensely helpful. Among them, Layla Diba, Mahnaz Afkhami, Michael Brenson, Pari Shirazi, Faye Ginsburg, Barbara Abrash, Andrew Lee, George Yudice, and Vera Jelinek have provided invaluable advice on negotiating the complex issues such a project addresses. The administration of NYU has also provided invaluable support at critical stages; in particular, we truly appreciate the commitment and encouragement of Vice-Provost Farhad Kazemi, Vice-President Robert Berne, and Vice-President Lynne Brown. Others at NYU who offered insight and expertise include John Beckman, Richard Pierce, Michael Haberman, Robert Cohen, and Alexis Offen.

We are greatly indebted to the lenders who made it possible to both exhibit and illustrate works from their holdings. At the Hoover Institution at Stanford University, we thank Elena Danielson, Cissy Hill, and former staff member Edward Jajko for their assistance in borrowing a number of revolutionary posters from their extensive collections. Likewise, Bruce Craig has facilitated the loan of key works from the Middle East Documentation Center at the University of Chicago Library, as did Nicky Nodjoumi, an artist who himself helped to organize one of the poster workshops at the University of Tehran in the late 1970s. At the Museum of Modern Art in New York, we thank Gary Garrels, Cora Rosevear, Francesca Pietraopaolo, and Mikki Carpenter. At Magnum Photos, New York, Kim Bourus and David Strettell provided key assistance.

At the Grey Art Gallery, we are most grateful to Frank Poueymirou, Michèle Wong, Lucy Oakley, Christopher Skura, David Colosi, Gwen Stolyarov, and Jennifer Bakal. As always, their commitment and professionalism were absolutely essential. At the Hagop Kevorkian Center, William Carrick and Barbara Pryce were both extraordinarily helpful, accommodating, and patient. Over the years, several NYU graduate students worked as research assistants on various aspects of the project. In particular, Bragan Thomas and Karen Kurczynski devoted much energy and enthusiasm, as did Afsaneh Dabashi and Mariani Lefas-Tetenes.

Iradj Bagherzade of I.B.Tauris went far beyond the call of duty in bringing this publication to fruition. His efforts came at a particularly crucial

period, and we are truly grateful for his help. Deborah Susman at I.B.Tauris expertly oversaw the book's production. Lucy Oakley and Robert McChesney very graciously advised on the editing of this volume.

The Rockefeller Foundation's efforts to illuminate issues concerning modernity in non-Western cultures are truly gratifying. We thank Raymund A. Paredes and Tomas Ybarra-Frausto of the Creativity and Culture program for their advice and generous support. Jane Gregory Rubin—a friend of Abby Grey's whose concern for her collection has not wavered over the years—provided much-needed funding at a key point, and we gratefully acknowledge both her and the Reed Foundation for their munificent contribution. Similarly, we express our deepest gratitude to the Soudavar Memorial Foundation and the Iran Heritage Foundation for their funding in support of this publication. At NYU, the Offices of the Provost, Academic and Health Affairs, and Student Affairs made essential contributions. This project also received funding from the Flora Family Foundation. Additional support was provided from the Hagop Kevorkian Center's grants from the U.S. Department of Education and the Ford Foundation's Crossing Borders program. As always, the Abby Weed Grey Trust has helped underwrite this—as well as every other—project at the Grey Art Gallery.

We are profoundly grateful to everyone mentioned above as well as to many others too numerous to name, for their input and assistance. The publication, exhibition, and the related series of educational programs would not have been possible without their support.

SHIVA BALAGHI
Associate Director, Hagop Kevorkian Center, New York University

LYNN GUMPERT
Director, Grey Art Gallery, New York University

INTRODUCTION

by Lynn Gumpert

OR TOO LONG, THE RICH and layered modern visual cultures of non-Western societies have been summarily dismissed as derivative of Europe and America. Only recently, for example, have we begun to seriously address the myriad of ways that many Middle Eastern artists have reconciled sophisticated and multifaceted cultural legacies with contemporary sensibilities. Here, the visual culture of Iran during the 1960s and 1970s presents a point of departure not only for looking at modern Persian art but also for examining urgent social issues, such as the politicization of Islam. How did a country—one that was heralded as a paragon of universalistic modernization—undergo an Islamic revolution whose message was steeped in localized imagery demanding an idealized return to the past? Serving as a testament to creativity as well as a historical record of upheaval and crisis, the visual arts can provide unique insights. The essays included in *Picturing Iran: Art, Society and Revolution* are thus intended to function as an introduction both to Iran's rich artistic heritage and to the complex political situation that culminated in the establishment of an Islamic state.

The collection of modern Iranian artworks housed at the Grey Art Gallery served as one of the initial inspirations for this volume and for an exhibition held at New York University in 2002. Part of the Abby Weed Grey Collection of Asian and Middle Eastern Art, they offer a splendid vantage point from which we can begin to study the art made in Iran in the 1960s and 1970s, both in greater depth and within a larger cultural context. Similarly, the photographs by Abbas illustrated here provide critical information about Iranian society in the crucial decade that culminated in the 1979 Revolution. Abbas, who was born in Tehran but who largely grew up and was educated abroad, made numerous trips back to his native country during the

1970s with the express purpose of producing a photo-essay examining the impact of the nationalization of the oil industry on Iranian society. One visit coincided with the outbreak of the Revolution. Between 1978 and 1980 Abbas shot hundreds of photographs: these provide startling and vivid views of Tehran and its citizens caught up in the throes of a whirlwind.

Likewise, the Iranian revolutionary posters reproduced here offer a fascinating glimpse into modern Iranian visual culture. Composed of bold forms and intense colors, such as red (identified with Marxist liberation movements) or green, black, and white (significant in Islam), and often incorporating calligraphy, these posters were ubiquitous throughout Tehran during the uprising. Along with graffiti, they covered the walls of Iran's cities and defaced the public monuments built by the Pahlavi regime as symbols of its authority and grandeur. [Fig. 1; Fig. 2; Fig. 3] Produced in makeshift workshops by both professional and amateur artists, the posters appeared

Fig. 1. ANNABELLE SREBERNY.
Men Before a Wall with Revolutionary Posters, Tehran. c. 1979.
Gelatin silver print.
5 x 7 in. (12.7 x 17.8 cm).

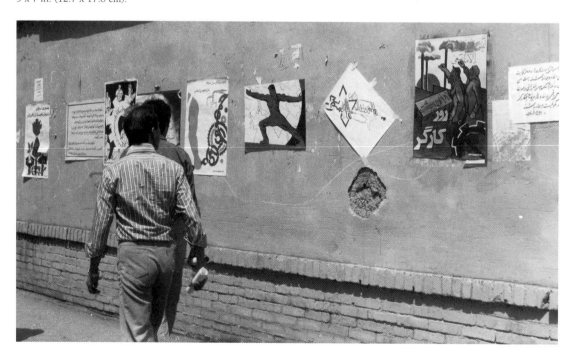

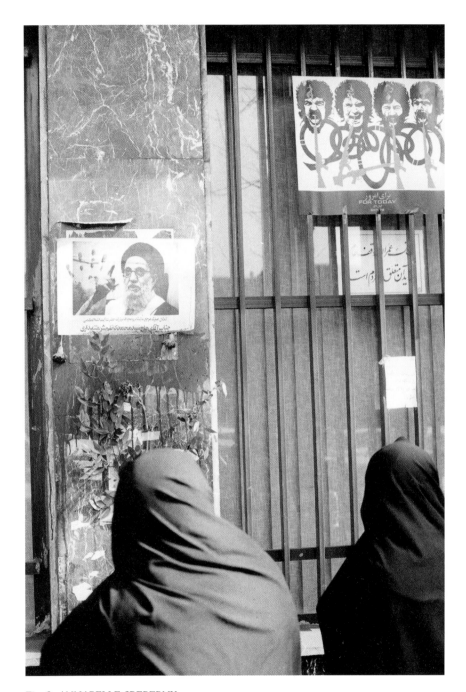

Fig. 2. ANNABELLE SREBERNY.
Women Before a Wall with Revolutionary Posters, Tehran. c. 1979.
Gelatin silver print.
7 x 5 in. (17.8 x 12.7 cm).

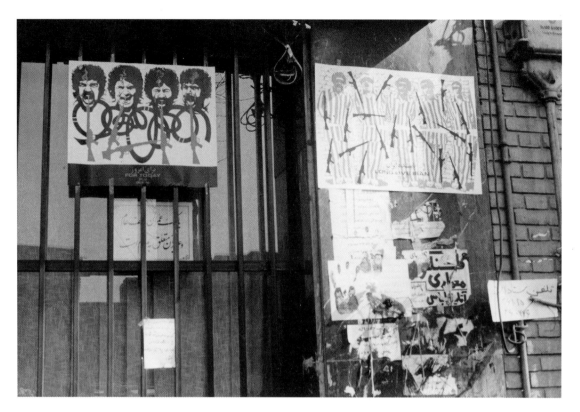

Fig. 3. ANNABELLE SREBERNY.
Wall with Revolutionary Posters, Tehran. c. 1979.
Gelatin silver print.
5 x 7 in. (12.7 x 17.8 cm).

seemingly overnight; as government agents tore them off or covered them with paint, protesters would replace them with replenished supplies. Alluding to battle scenes from the Koran or classical Persian poetry and intending to convey abstract ideologies to large numbers of people, the posters merged calligraphy, rhetoric, and politics. Indeed, it is precisely this interplay between word and image—as well as between past and present—that this publication and the 2002 exhibition explore.

Iranian painters and sculptors of the 1960s and 1970s also turned to their heritage for inspiration, in particular to Persian poetry, Shiite folk art, and traditional Islamic themes. Linking the ancient with the modern and fusing the sacred with the profane, they, like the poster artists that followed them, exploited the graphic potential of calligraphy—which functions simul-

taneously as both word and image—to arrive at powerful abstractions. Some of the posters even appropriated and recycled elements from photographs reproduced in local newspapers. Thus art, reportage, poetry, and politics formed a tightly interlocking web of meanings in Iranian visual culture of the time.

In her essay "Iranian Visual Arts in 'the Century of Machinery, Speed, and the Atom': Rethinking Modernity," Shiva Balaghi, my coeditor, examines modernism from a Middle Eastern perspective. Tracing the history of modernity in Iran, she reveals how artists there experimented with and embraced both nationalist and religious tropes, foreshadowing, to an extent, the 1979 Revolution. As she points out, visual artists in Iran during these two critical decades increasingly took on the role previously assigned to poets—that of the voice of political conscience and dissent. In her essay "Writing with Light: Abbas's Photographs of the Iranian Revolution of 1979," Professor Balaghi discusses how Abbas's work unflinchingly details the way in which a populist movement turned into a violent conflagration, how spontaneous rioting was redirected into a choreographed mass performance. Following in the tradition of Henri Cartier-Bresson, Abbas—who recently served as President of Magnum, the world-renowned photojournalists' collective—was both an observer and a participant. The relevant entries from his diaries, which accompany the photographs in the 2002 exhibition, clarify his own position. "Writing with light," Abbas himself notes, has become his *modus operandi*.

Fereshteh Daftari, Assistant Curator at the Museum of Modern Art in New York, argues that modernism in Iran was an alternative movement with its own definition, its own chemistry, and its own internal logic. In her essay "Another Modernism: An Iranian Perspective," she locates the origins of modern Persian painting at the turn of century, when a number of artists returned to Iran after studying abroad and established the first professional art schools. Providing an overview, she identifies the major critics, exhibitions, and galleries that constituted the lively art scene in Iran in the 1960s and 1970s, including the Saqqakhaneh movement, which is well represented in the Grey Collection.

Haggai Ram, Associate Professor of Middle East Studies at Ben-Gurion University of the Negev in Beersheba, Israel, highlights the genealogy of revolutionary ideology, demonstrating how the posters contained different, sometimes conflicting, messages. In "Multiple Iconographies: Political Posters in the Iranian Revolution," he details how the posters helped redefine cultural and social values. In particular, he traces how their multiple icono-

graphies referred to both Shiite Islam and Persian history. Finally, Peter Chelkowski, in his essay "The Art of Revolution and War: The Role of the Graphic Arts in Iran," reveals how posters—as well as postage stamps and banknotes—took on different functions after the Revolution. When Saddam Hussein invaded Iran in 1980, the graphic arts faced a new challenge: "to rally the nation to the defense of the country and repel the aggressor."

Picturing Iran sheds light on the many ways that visual culture both reflected and affected the tumultuous two decades of the 1960s and 1970s in Iran. Modern Iranian artists grappled with questions of how to reconcile their modern concerns with their Persian heritage, or, as Abby Grey observed, how they could break "with the past to cope with the present." They found—as we can see in the resulting artworks—a plethora of visual solutions that transcended the gaps between mimicry and rejection. Their artistic expressions take on greater meaning as our understanding of modernity deepens, and as we gain new insights into the role art can play during times of political crisis.

REFLECTIONS ON
THE ABBY GREY COLLECTION

by Lynn Gumpert

How did a self-described "dyed-in-the-wool Midwesterner" residing in St. Paul, Minnesota, come to donate over two hundred works of modern Iranian art to New York University (NYU)? Indeed, this group of works—part of The Abby Weed Grey Collection of Asian and Middle Eastern Art at the Grey Art Gallery—constitutes the largest public holding of Iranian modern art outside of Iran. This unusual collection was amassed by Abby Grey on numerous trips to Asia and the Middle East in the 1960s and 1970s to promote artistic exchange, and represents countries as diverse as Japan, Thailand, India, Nepal, Turkey, Israel, and, of course, Iran.[1] In 1974, Mrs. Grey established the Grey Art Gallery at NYU as a permanent home for her collection with the intention of furthering her cross-cultural approach in an international academic setting as well as complementing NYU's Hagop Kevorkian Center for Near Eastern Studies.

Mrs. Grey, it turns out, had begun collecting art as part of a mission of self-education. She created the Ben and Abby Grey Foundation in St. Paul in 1961 in order to sponsor and encourage artists, and to purchase their works to exhibit in the future. She later remarked that, in hindsight, she realized "how naïve and uncritical I was about the whole enterprise. But had I been more worldly and 'realistic,' I never would have undertaken what I did." Indeed, despite "a lack of professional expertise," she continued, "I was able to arrange the first exhibition of original contemporary American art to be seen by Turkish and Iranian artists. Moreover, my informal contacts with these and other third-world artists laid the groundwork for precedent-setting shows in the United States."[2]

Her vision was bold and simple: one world through art. She believed that art, as a universal language, could serve as a potent vehicle of knowledge, communication, and understanding. Born in 1902 in St. Paul, she married Benjamin Edwards Grey, a career army officer, in 1930. She started collecting in earnest in 1960, after the death of her husband four years earlier. It was at the age of 58, after travelling around the world with a group of fourteen women, that she identified her new and most unusual direction. She realized early on that what interested her was not the traditional or conventionally appealing but, rather, responses "to a world both beautiful and ugly; works that were arresting and strange, demanding that, through art, I perceive and understand reality in a deeper way."[3] For instance, in India, "I didn't look for miniaturists or gem setters; in Iran, I didn't look for rugmakers. In many places, I didn't know where to look or exactly what to look *for*, but whatever it was going to be, it had to express the response of a contemporary sensibility to contemporary circumstances. In every country, I asked, 'Where are your working artists? What are they doing? How are they breaking with the past to cope with the present?'"[4]

Her engagement with the art and artists of Iran was especially impassioned. Mrs. Grey's first trip to Iran in 1960 coincided with the second national biennial of modern art, which was on view at the Golestan Palace in Tehran, and which she described as "an eye-opener." Home to the famous Peacock Throne, the palace was full of "glitter and more glitter ... marble floors covered with Persian rugs, gardens of pansies, fountains jetting rainbows in the setting sun, chandeliers, mirrors inside and out. Lots of sparkle but no life."[5] In her visits to studios—in Iran and elsewhere—she found what she was looking for: artists who were not just practicing age-old traditional arts, often geared for the tourist market, but instead eager to break away from clichés and contribute to the changing world around them. On her second trip to Iran and Turkey in 1961, she took with her a portfolio of ink drawings, prints, pastels, and other works on paper by contemporary Minnesota artists in order to allow artists to see actual works—as opposed to reproductions—by their Western counterparts. Eventually, Mrs. Grey's efforts resulted in a number of touring exhibitions, both in the United States and abroad, some undertaken in collaboration with the United States Information Service (USIS).[6] In 1972, she realized her most ambitious project to date—a show titled "One World Through Art," consisting of 1,001 works (the number inspired by the classic Arabian tales), held at the Minnesota State Fair Grounds. She also arranged for international exchanges, enabling two young

Iranian artists, Parviz Tanavoli and Siah Armajani, to spend time in Minnesota. With the aid of Tanavoli, she established a bronze foundry at the University of Tehran where this artist, eager to revive an ancient Persian art form, taught after his return from St. Paul to Iran.

In 1970, Mrs. Grey began watching one of the first attempts to broadcast university-level courses on television. Called Sunrise Semester, the series appeared on CBS. Three mornings a week, at 6.00 am, NYU professor Peter Chelkowski lectured on Persian history. On one of her trips to New York to visit her brother, who was a pastor at St. Luke's Chapel in Greenwich Village, Mrs. Grey contacted Professor Chelkowski to discuss their shared enthusiasm for Persian culture. From that initial contact, a link was forged. With the inaugural show at the Grey Art Gallery in 1975, NYU was able to exhibit both the art it had acquired over the years and the modern Asian and Middle Eastern works received from the Grey Foundation.

Truly multicultural before her time, Abby Weed Grey actually achieved what she set out to do, not only encouraging and sponsoring contemporary artists, but ensuring that their works would be seen and studied in the future. Illustrated here, within a larger context of modern Iranian visual culture, it is clear that her collection continues to educate and inspire.

NOTES

1 Abby Weed Grey, *The Picture Is the Window, The Window Is the Picture: An Autobiographical Journey* (New York: New York University Press, 1983), p. 3.

2 Ibid., p. 69.

3 Ibid., p. 17.

4 Ibid., p. 15.

5 Ibid., p. 43. In her memoirs, Mrs. Grey mistakenly identifies the show as the first biennial of modern art. However, as discussed by Fereshteh Daftari in this volume, it was actually the second show. The first took place in 1958.

6 See Shiva Balaghi, "Iranian Visual Arts in 'The Century of Machinery, Speed, and the Atom': Rethinking Modernity," in this volume, which details an exhibition of contemporary Iranian art that Abby Grey helped organize. A show of the works of contemporary Minnesota artists, titled *Minnesota Art Portfolio* (MAP), was exhibited in some European cities and Tehran before being circulated by USIS. See Grey, pp. 51–77.

IRANIAN VISUAL ARTS IN "THE CENTURY OF MACHINERY, SPEED, AND THE ATOM": RETHINKING MODERNITY

by Shiva Balaghi

AMERICAN AUDIENCES WERE FIRST introduced to modern Iranian art through a show entitled "Exhibition of Iranian Contemporary Paintings," which traveled throughout the country in 1962.[1] In a brief essay published in the accompanying catalogue, Akbar Tajvidi addressed one of the central questions concerning Iranian art from the 1960s.[2] Is this art *modern*, and if so, is it particularly *Iranian* in its character? He wrote:

> If some of the works show an inclination towards "informal" or "abstract" style, they should not be considered as an imitation of western art, but rather, it should be borne in mind that we, too, are living in the Twentieth Century. Though we may in some ways differ from the citizens of the western world so far as our material life is concerned, we are confronted with the same problems as they. We, too, are living in the Century of Machinery, Speed, and the Atom. Our feelings and emotions cannot be unrelated to the time in which we live … Though it is a quality of the world in which we live that similar cultural phenomena manifest themselves throughout the world at a sigle [*sic*] time, it is our hope that the ways now adopted by our

artists will lead them to a new form of expression which, apart from having the characteristics of the new world, may also be instrumental in making known this corner of the world which we call the New Iran. So that we, too, may contribute our share of the variety on which the world of art depends.[3]

In important respects, the 1962 exhibition, which included fifty works by fourteen artists, serves as a window onto the history of Iranian art in this period. Curated under the auspices of the Fine Arts Administration of Iran, the exhibition paired some of Iran's established contemporary artists active since the 1950s, such as Javad Hamidi and Ahmad Esfandiari, with younger artists like Mansoor Ghandriz, Parviz Tanavoli, and Hossein Zenderoudi. Some of the featured artists were women, including Behjat Sadr. Most of the artists had studied at the School of Fine Arts of the University of Tehran.[4] By 1962, many had exhibited their work in Tehran's galleries and had participated in the Tehran Biennials.

Interestingly, some forty years later, we find ourselves still confronting the central issue: is this art modern and is it Iranian? As one maps out the history of modern art from the twentieth century, should non-Western art be relegated to the margins, viewed as a derivative and imitative reflection of the canonical art produced in the West? The question of mapping the modern is not limited to matters of the arts alone. Leading scholars of India, the Middle East, and even the "backward" parts of Europe have challenged commonly held notions of modernity. As Timothy Mitchell argues, "In many uses, the modern is just a synonym for the West (or in more recent writings, the North). Modernization continues to be commonly understood as a process begun and finished in Europe, from where it has been exported across ever-expanding regions of the non-West. The destiny of those regions has been to mimic, never quite successfully, the history already performed by the West. To become modern, it is still said, or today to become postmodern, is to act like the West."[5] As Mitchell shows, this view overlooks the imperial context of "the rise of the west." And as Geoff Eley argues in his discussions of modernity in the German context, the established narratives of Western civilization that assert and maintain its cultural authority can suppress alternative histories.[6] The notion of a monolithic modernity rooted in post-Enlightenment Europe with unilinear flows of influence and exchange obfuscates the imperial implications of modernity for the non-Western world and can inhibit a serious examination of the actual content and context of local

histories of the modern outside of Europe.[7] Too often, the cultural history of the post-1945 Middle East is perceived as an uneasy tension between "tradition" (native, authentic, Islamic) and "modernity" (imported, mimetic, secular).

In order to resolve this tension, some scholars turn to the notion of hybridity. At times, their conceptualization of hybridity divides art into form, which is learned in and borrowed from the West, and content, whose raw material is abstracted from national cultures. This explanation of non-Western modern art simply confirms the Europeanness of modernity by fusing localism (traditional, immutable) with universalism (modern, developing). In this equation, the methods and techniques of the West are the necessary agents for awakening the placid cultural life of the East. Wedded together, the traditional and the modern produce an anachronistic art, a cultural by-product that does not refute the distinct division of the world into East and West. Viewed in such a manner, histories of alternative modernities ultimately relocate the genesis, engine, and structure of the modern completely within Europe—and a Europe that exists outside of the historical, economic, and cultural impulses of empire. This concept of the modern was shaped by the metropole with no substantive input from or impact on the colonial.[8] A more useful model of cultural hybridity is posited by Homi Bhabha who points out that questions of power and of resistance are mutually constitutive. The mimicry of cultural hybridity, according to Bhabha, is "at once a mode of appropriation and of resistance."[9]

Iranian artists in the 1960s and 1970s were engaged in the search for a solution to the "problem of culture" under capitalism.[10] In the cultural lexicon of Iran, the "West" did not simply represent a higher civilizational model to be emulated, but an imposing presence on its national autonomy. Recent history had seen Iran struggling to maintain its independence as a focus of Russo-British "Great Game" colonial intrigue throughout the nineteenth century and as a site of imperialist geopolitical and economic interests in the twentieth century. And it was in the context of "the long nineteenth century" of the Qajars that culture became an important site for the colonial–national contest; therein lie the origins of Iranian modernity.[11] In part, then, the construction of modernity in Iran was an act of resistance through the reproduction of a local, national culture. Iran's shifting position in the post-World War II international economy—from that of quasi-colonized loan seeker to major oil producer—resulted in a fusion of the historical and the present, the universal and the local on the Persian canvas. Clearly, Iranian artists were contributors to, and not simply recipients of, modernity. As we review the

artworks discussed in this publication, then, it seems worthwhile to shift the ground of our inquiry. Rather than focusing exclusively on whether this art is modern, we may ask how this work might expand our understanding of modernity itself.

Like artists working in Paris and New York, artists in Tehran lived in "the Century of Machinery, Speed, and the Atom." They, too, recognized the need for new forms of cultural production that could record, explain, reconcile, and perhaps even alter the realities of the time and place in which they lived. A search for meaning shaped their creative impulse and their drive to break from the past and to create new forms of art.[12] Recasting tropes of classical literature into a vernacular visual language, infusing the symbols of Shiism with worldly concerns, and subverting the order of "the art of the book" with its highly ritualized calligraphy and miniature paintings, these artists imagined ways to exist as Iranians within a modern consumer society.[13] Iranian artists made use of pre-existing materials and symbols in Persian culture and infused them with new constellations of meaning. Their work suggests that modernity in the Iranian context was a complex field of negotiation and accommodation—and not a simple act of imitation and mimicry. As Fereshteh Daftari shows in her essay in this volume, the work of these artists must be viewed within an expanding institutional context—the developments in art criticism, the establishment of an exhibition and gallery apparatus, and the shifting patterns of education and patronage that influenced Iranian art in this period.

The essays and images that appear in *Picturing Iran: Art, Society and Revolution* help to delineate significant changes in Iranian visual art from the 1960s and 1970s—changes that can be seen in the poetics and iconography of this art and in the increasingly social role of the artist. These aspects are apparent in the work of Parviz Tanavoli, a sculptor, painter, lithographer, collector, and scholar of Persian art.[14] Tanavoli is considered one of the leading practitioners of Saqqakhaneh art, a movement that Iranian art critic Karim Emami characterizes as "approaching, if not exactly creating, an Iranian school of modern art."[15] Emami originally used the term Saqqakhaneh in 1962 to describe an artistic approach that integrated populist themes from Iranian Shiite folk art into modernist art. Kamran Diba, the former director of the Tehran Museum of Contemporary Art, wrote, "The discovery of concepts and visual symbols of primitive religious rituals, in the form of prayers and spells devoid of traditional formalism excited the artist. The result was that he began to explore in his work a new vocabulary of motifs."[16] Diba

Fig. 4 PARVIZ TANAVOLI.
Oh, Nightingale! 1974.
Lithograph.
27 ³/₄ x 20 ¹/₂ in. (70.5 x 51.1 cm).

evocatively referred to this movement as Spiritual Pop Art: "There is a parallel between *Saqqak-khaneh* and Pop Art, if we simplify Pop Art as an art movement which looks at the symbols and tools of a mass consumer society as a relevant and influencing cultural force. *Saqqak-khaneh* artists looked at the inner beliefs and popular symbols that were part of the religion and culture of Iran, and perhaps, consumed in the same ways as industrial products in the West."[17]

Tanavoli's work clearly draws on the popular symbols of Iranian culture, as seen in his *Oh! Nightingale,* a lithograph from 1974. [Fig. 4] A complex layering of symbolism and technique, the lithograph was made as a study for the design of a rug and suggests a connection between modern robots and tribal Persian designs.[18] The work depicts an angular robotic figure sitting in a kneeling position and holding a nightingale. His mouth forms a grid, with two large red locks sealing his lips shut. The interplay of word and image is central, with one abstract calligraphic notation hinting at the name of God, another depicting the name of Ali (a descendant of the Prophet Mohammad). The nightingale is celebrated in Persian literature for its passionate song; here, the robotic figure holding the bird is unable to speak. Reworking tropes from classical Persian literature, Islam, rug weaving, and calligraphy, Tanavoli produced a work that provocatively unites style and meaning. Tanavoli's lithograph is undeniably both modern and Iranian.

In 1972, Tanavoli sculpted *Heech*, a bronze statue formed in the arching shape of the Persian letters that spell out the word, "nothing." [Fig. 5] He reproduced the same shape in various sculptures, pieces of jewelry, and ceramic works. In an important study of calligraphy, Annemarie Schimmel commented on Tanavoli's interpretation

Fig. 5. PARVIZ TANAVOLI.
Heech. 1972.
Bronze.
22 1/2 x 11 1/2 x 5 in. (57.2 x 29.2 x 12.7 cm).

of the Persian letter, "The letter ha' ... is called 'two-eyed' in its initial and central shape and was therefore interpreted, at least from Sana'i's time onward, as weeping ... The contemporary Persian sculptor Tanavoli has very well expressed this sadness of the *h* in his delightful variations on the word *hich* (nothing) ..."[19] Calligraphy, a highly revered aspect of Islamic art, has historically held multiple meanings. As Schimmel explains, "The letters are the expression of something of a higher order. The thinkers and literati generally mused on the relations between the written word and its hidden meaning, whereas the mystics' experience of the letters of the Arabic alphabet was that they had a very special quality."[20] In his modern renditions, Tanavoli restated the importance of the written word as a form that is open to multiple interpretations. Drawing on the Sufis and poets of earlier times, he turned to calligraphy to show the apparent futility of the search for meaning in words while seeking solace in the abstract shapes of letters.

The trope of calligraphy reappears with notable frequency in the work of Iranian artists in this period, but is perhaps most closely associated with the artist Hossein Zenderoudi, who is credited with being the first Saqqakhaneh artist.[21] In his painting *The Golden Shower*, 1966, tiny calligraphied illegible letters tumble into an aimless mound. The careful mechanistic repetition of orderly, perfectly formed letters, an integral part of the calligrapher's training and practice, is swept away in a grand gesture that disembodies calligraphy from its time-honored rituals and empties words of their meaning. This dissonant calligraphic form not only recalls and reifies the Islamic art of the book, it signals a shift in the relationship between the word and the image. If Zenderoudi's calligraphy creates a new representational lexicon, it also links Iran's modernity with its past. In a work on paper by Zenderoudi from 1960, calligraphy embellishes and adorns the *shir-o-khurshid* or "The Sun and the Lion." [Fig. 11] From pre-Islamic times, the lion has been an important icon in Iranian art.[22] The walls of the ancient palace of Persepolis depict the Achaemenid lion in various forms, here standing guard over Darius's domain, there battling the Babylonian bull. In the nineteenth century, the lion and the sun were brought together to forge an official emblem for the state. Another work by Zenderoudi from the Grey collection, *The Hand*, makes liberal use of calligraphy and clearly references Shiite folklore.[23] [Fig. 6] In his use of calligraphy, Zenderoudi threads together religious, nationalist, and literary references, ultimately creating a new visual language, that has been called an "epistemological aesthetic."[24]

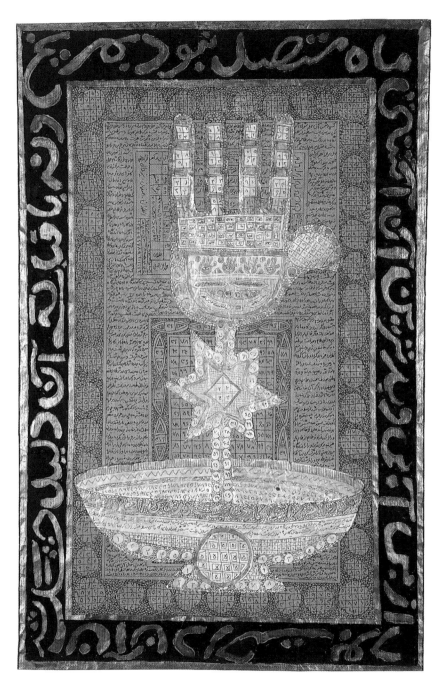

Fig. 6. HOSSEIN ZENDEROUDI.
The Hand. c. 1960.
Paper collage with ink, watercolor, and gold and silver paint.
26 ¼ x 17 ½ in. (67.9 x 44.5 cm).

Fig. 7. SIAH ARMAJANI.
Calligraphy. 1964.
Ink on canvas.
60 x 41 ¹/₂ in. (152.4 x 105.4 cm).

We encounter calligraphy once again in the work of Siah Armajani, whose art links calligraphy with the tradition of Persian poetry as a form of social critique. Armajani was born and raised in Iran and moved to the United States as a college student; he is now considered one of the most important public artists in America. The Grey collection includes several early works by Armajani that reflect his interest in poetry, philosophy, and populism, and demonstrate ways in which he fused aspects of Iranian and American culture to create unique forms of art. In *Calligraphy*, 1964, undulating stanzas of calligraphic Persian poetry cover a white canvas with a dense network of lines flowing in various directions. [Fig. 7] This work reflects a reverence for calligraphy, even as it subverts the careful orderly rules of the calligraphic arts. The canvas at once underlines the importance of poetry, while it renders the words into an illegible, dizzying confluence of images and forms. Growing up in Iran with a father who held poetry in high esteem, Armajani had learned the power of the poet: "Poets are venerated in Persian culture … The poets always have the truth. You know, in Iran, poets were the only ones who were allowed to voice political and social protest. If you expressed yourself in prose, you got arrested. If you expressed yourself in poetry, no one would touch you."[25]

Clearly, the relationship between word and image was a central concern to Iranian artists working in the 1960s and 1970s. As W.J.T. Mitchell argues, one of the central tasks of abstract painting was "the erection of a wall between the arts of vision and those of language;" thus modernism in the visual arts involved "a certain resistance to language."[26] Mitchell expanded on Michel Foucault's concept of the "calligram," a text-image that reconstitutes the collaboration between the written and the visual, "an alliance between the shapes and meanings of words."[27] The calligraphic notation is a central element in the works of Tanavoli, Zenderoudi, and Armajani. In the context of Iranian modernism, the text-image dialectic has particular cultural references. These artists' visual dialogue, then, engaged the universalism of modernity and the localism of Iranian culture. Foucault viewed the text-image dialectic as an important site for the production of knowledge; so, too, Iranian artists drew on this synergetic relationship to create new spaces for social criticism. Increasingly, the role of the artist was fused with that of the poet, the long-standing conscience of Iranian society.

This symbiotic relationship between the word and the image that forged a new cultural space for social criticism in Iranian art became more fully manifest in the graphic arts. As social discontent increased throughout

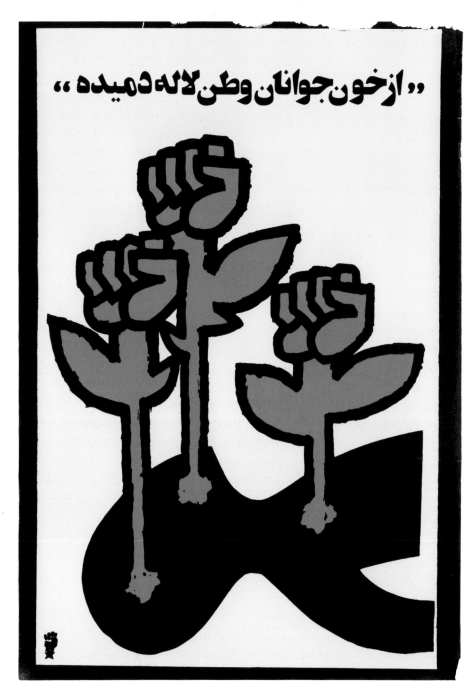

Fig. 8. MORTEZA MOMAYEZ.
Poster depicting fists as tulips. c. 1978–79.
19 x 13 in. (48.3 x 33 cm).

the 1970s, some of Iran's leading contemporary artists became involved in the production of political posters. These posters form a historical record of the role of the visual arts in the Iranian Revolution of 1979. In an article in this volume, "Multiple Iconographies: Political Posters in the Iranian Revolution," Haggai Ram examines the revolutionary posters as a site of "insurgent consciousness." Tracing the iconography in some of the posters, Ram shows the complex cultural references that informed this revolutionary art.[28] Inspired by the French student movement of 1968, a group of Iranian artists opened a workshop for poster production at the University of Tehran in 1978. The workshop provided the materials and equipment for printing posters to members of various political groups. Amateur artists worked alongside some of the leading contemporary Iranian artists. The posters were displayed throughout Tehran—in schools, in factories, and on the walls of buildings.[29] Morteza Momayez, an active member of the poster workshop, was featured in the 1962 exhibition of Iranian art that traveled to the United States, and the Grey collection includes several of his works.[30] His posters clearly display the fusion of symbolism that marked Iranian modern art in this period.[31] In one poster, three red tulips in the shape of clenched fists are topped with an excerpt from a poem that reads: "Tulips have blossomed from the blood of the nation's youth." [Fig. 8] The poster reveals the multifarious influences that propelled Momayez's revolutionary message: the symbol of the American civil rights movement (the raised fist) merges with an icon from classical Persian literature (the tulip). Persian poetry provides the defiant slogan. These posters demonstrate how the visual arts came to function as a more direct and urgent form of social intervention. Breaking free from the institutional context of art production and presentation, artists took their works directly to the street.

The photographs taken by Abbas in the 1970s depict gripping images of Tehran's streets. In my essay included in this volume, "Writing with Light: Abbas's Photographs of the Iranian Revolution of 1979," I characterize Abbas as a "committed photographer."[32] Describing his work on Iran, he says, "This is not anonymous photography."[33] Perhaps it is his propensity to produce art with a distinct point of view that has rendered writing such a central component of his work as a photographer. For Abbas, photography is a synergetic relationship between word and image. "Photography can be interpreted in so many different ways. The same picture can mean different things to different people. One of the reasons I write and publish my writing in my books is to show my point of view. With the words, I can emphasize

my interpretation, my meaning of the picture."[34] An avid diarist, Abbas relies on writing as a part of the process of making pictures. His books usually include excerpts of his diaries, so writing is integral to the presentation of his pictures as well. In his *Allah O Akbar*, a journey book depicting the vast Islamic world, Abbas interlaces his photographs and his words, recalling the medieval Persian illuminated manuscript. In that tradition, the words and the pictures can stand alone but develop a more textured meaning when taken together as a single art form.

Clearly, as the essays in this volume demonstrate, Iranian art from the 1960s and 1970s offers a rich historical tableau. This art drew on the rich intertextuality between word and image. It brought together historic and contemporary forms; its content contained a complex range of iconographies. Its major task was a search for meaning, a desire to make works of art that were relevant in a "New Iran." This process ultimately translated into the creation of a visual culture that both influenced and reflected socio-political currents that became manifest in the Iranian Revolution of 1979. Perhaps we have finally arrived at a place where we no longer need to ask if a work of art can be both modern and Iranian. Instead, we may ask if our understanding of the modern aesthetic takes on a different resonance when we take into account disparate geographies and multiple histories of modernity.

NOTES

Haggai Ram, Timothy Mitchell, Lynn Gumpert, and Lucy Oakley deserve my gratitude for patiently reading and commenting on various drafts of this essay. Fereshteh Daftari, Layla Diba, and Nicky Nodjoumi's intellectual companionship has helped me to better appreciate the importance of the visual arts for understanding the history of modernity in Iran.

1 Abby Weed Grey was an important supporter of contemporary Iranian art in the 1960s and 1970s; she donated her extensive collection of Iranian art to New York University. For information on her activities relating to Iranian art, see her *The Picture Is the Window, The Window Is the Picture* (New York: New York University Press, 1983). "An Exhibition of Iranian Contemporary Paintings" opened in Tehran on February 17, 1962. After the opening, Parviz Tanavoli accompanied the exhibition as it traveled to the United States, offering lectures on Iranian art at some of the exhibition venues. The show was mounted in Chicago, Washington, D.C., and New York, and on a subsequent tour it traveled to Minnesota, Utah, Oregon, Washington, Idaho, New Mexico, and Texas. The title of the exhibition changed at some venues; for example, the show at the Minneapolis School of Art from June 8–July 13, 1962 was entitled "14 Contemporary Iranians." My own interest in Iranian art from this period was fuelled by the Grey Collection and my work as one of the key organizers of the exhibition "Between Word and Image: Modern Iranian Visual Culture," which was

mounted at New York University's Grey Art Gallery in 2002.

2 Akbar Tajvidi's *L'Art Moderne en Iran*, published by the Ministry of Fine Arts and Culture in 1967, is considered the first scholarly study on the subject. Tajvidi is a painter and art critic who was involved in organizing Tehran Biennials. According to Fereshteh Daftari, he was in a sense "the official art expert" during the period. Other important studies on modern and contemporary Iranian art have been published by Ehsan Yarshater, Karim Emami, Kamran Diba, and Ru'in Pakbaz.

3 Akbar Tajvidi, introduction, *Iranian Contemporary Paintings* (Tehran, 1962).

4 For discussions of the schools offering training for artists in Iran, see Fereshteh Daftari, "Another Modernism: An Iranian Perspective," in this volume; Karim Emami, "Post-Qajar (Painting)" in *Encyclopaedia Iranica,* ed. Ehsan Yarshater, vol. 2 (London and New York: Routledge and Kegan Paul, 1987), pp. 640–46.

5 Timothy Mitchell, "The Stage of Modernity," in *Questions of Modernity*, ed. Timothy Mitchell (Minneapolis: University of Minnesota Press, 2000), p. 1. As Edward Said has argued, "Modernity is crisis, not a finished ideal state seen as the culmination of a majestically plotted history." See Edward

Said, "History, Literature, and Geography," in his *Reflections on Exile* (Cambridge: Harvard University Press, 2000), p. 473.

6 Geoff Eley, "German History and the Contradictions of Modernity: The Bourgeoisie, the State, and the Mastery of Reform," in *Society, Culture, and the State in Germany, 1870–1930*, ed. Geoff Eley (Ann Arbor: University of Michigan Press, 1996), p. 70.

7 Interestingly, though art criticism has neglected to examine the history of alternative modernities, institutions of modern art have not. Works by three of the artists in the Grey collection— Marcos Grigorian, Hossein Zenderoudi, and Faramarz Pilaram—are included in the permanent collection of the Museum of Modern Art, New York. See "The Museum of Modern Art, New York: Painting and Sculpture Acquisitions," *Museum of Modern Art Bulletin* 30, nos. 2–3 (1963); Karim Emami, "Modern Persian Artists," in *Iran Faces the Seventies*, ed. Ehsan Yarshater and John S. Badeau (New York: Praeger, 1971), p. 356. Some scholars who have set forth important critiques of the tradition of art criticism that shaped canonical modernism continue to ignore the history of modernity in the non-Western context, even as they point to the need to integrate gender, class, and race more fully into narratives of

modernity. See for example, Charles Harrison and Paul Wood, "Modernity and Modernism Reconsidered," in Paul Wood, Francis Franscina, Jonathan Harris, and Charles Harrison*, Modernism in Dispute: Art Since the Forties* (New Haven: Yale University Press, 1993), pp. 170–256; Thomas Crow, *Modern Art in the Common Culture* (New Haven: Yale University Press, 1996).

8 See Ann Laura Stoler and Frederick Cooper, "Between Metropole and Colony," in *Tensions of Empire: Colonial Cultures in a Bourgeois World*, ed. Frederick Cooper and Ann Laura Stoler (Berkeley: University of California Press, 1997), pp. 1–56.

9 Homi Bhabha, *The Location of Culture* (London: Routledge, 1994), p. 120.

10 For an important discussion of the complicity between modernism and consumerist society, see Crow, p. 19.

11 Ru'in Pakbaz wrote that the origins of Iranian modernity are rooted in the cultural origins of the Constitutional Revolution of 1906, suggesting that the modernist turn first took shape in the literary arts; see his *Da'irah al-Ma'arif-e Honar/Encyclopedia of Art* (Tehran, 1999), p. 889 and "Contemporary Art of Iran," *Tavoos* no. 1 (1999): 168. More research is needed on connections between visual arts in the Qajar and Pahlavi periods. Layla S. Diba made a

major contribution to our understanding of the importance of Qajar visual arts in Iranian modernity with the exhibition and catalogue *Royal Persian Paintings: The Qajar Epoch, 1785–1924,* ed. Layla S. Diba with Maryam Ekhtiar (London: I.B.Tauris in association with Brooklyn Museum of Art, 1998). Afsaneh Najmabadi is currently completing a study of gender and modernity in Qajar Iran that draws heavily on the visual arts. See her "Reading for Gender Through Qajar Painting," in ibid., pp. 76–89. See also Shiva Balaghi, "Political Culture in the Iranian Revolution of 1906 and the Cartoons of 'Kashkul'," *Princeton Papers,* Spring 1997, pp. 59–82, and "Mirza Abu Torab Ghaffari, Mirza Mehdi Khan Mossaver al-Molk, and the Illustrated Press in Qajar Iran," paper delivered at the conference "The Qajar Epoch: Culture, Art, and Architecture," University of London, September 1999.

12 "The borderline work of culture demands an encounter with 'newness' that is not part of the continuum of past and present," wrote Homi Bhabha. "It creates a sense of the new as an insurgent act of cultural translation. Such art does not merely recall the past as social cause or aesthetic precedent; it renews the past, refiguring it as a contingent 'in-between' space that innovates and interrupts the performance of the present." Bhabha, p. 7.

13 This reinvention of the Perso-Indian manuscript tradition can be seen in the work of Pakistani artist Shahzia Sikander, who trained at the National College of Art in Lahore. See "Miniaturizing Modernity: Shahzia Sikander in Conversation with Homi K. Bhabha," in *Public Culture* 11, no. 1 (1999): 146–51.

14 My discussion of Iranian art from the 1960s and 1970s in this essay is limited to works featured in the 2002 exhibition "Between Word and Image: Modern Iranian Visual Culture." That exhibition is based in large part on the Grey Collection, in which Tanavoli's work is very well represented.

15 Karim Emami, "Saqqakhaneh School Revisited," in *Saqqakhaneh* (Tehran: Tehran Museum of Contemporary Art, 1977).

16 Kamran Diba, preface, in *Saqqakhaneh.*

17 Kameran Diba, "Iran," in *Contemporary Art from the Islamic World,* ed. Widjan Ali (London: Scorpion Publishing, 1989), p. 153.

18 In the summer of 1975, the Grey Art Gallery presented "Lion Rugs from Fars," an exhibition of Persian carpets from Tanavoli's collection. The exhibition had previously traveled to Oshkosh, Wisconsin, and Washington, D.C. Tanavoli's catalogue essay clearly displays his great knowledge of and keen interest in Persian carpet design. See Parviz Tanavoli, "Introduction," *Lion Rugs from Fars* (1974).

19 Annemarie Schimmel, *Calligraphy and Islamic Culture* (New York: New York University Press, 1984), p. 139.

20 Ibid., p. 90.

21 See Fereshteh Daftari, "Another Modernism: An Iranian Perspective," in this volume; and the collection of excellent essays in *Saqqakhaneh.* In December 2001, an exhibition featuring the work of Hossein Zenderoudi and Massoud Arabshahi, entitled "Two Modernist Iranian Painters," opened at the Tehran Museum of Contemporary Art. On the museum's website, this art is celebrated for being both national *and* modern, "[The] tendency toward national ideals and identity along with practice of traditional Iranian motifs are prominent features in works of Iranian artists during the 1940's and 50's … [This art represents] a praiseworthy effort in establishing a 'national painting' emanating from Iranian identity by way of modern mode of artistic expression. " March 25, 2002 <http://www.ir-tmca.com>.

22 Iconography played an important role in pre-Islamic Persian religious and political life. See Roman Ghirshman, *The Arts of Ancient Iran,* trans. Stuart Gilbert and James Emmons (New York: Golden Press, 1964). It is interesting to note that André Godard, the first director of the School of Fine Arts at the University of Tehran in the 1940s, was himself an archaeologist, involved in important digs.

23 As one scholar explained, "The hand raised above all is both the hand of Abbas and the sign of the 'Panj-tan' or Five Holy Ones (Mohammad, his daughter Fatima, Ali, Hasan, and Husayn)." Peter Lamborn Wilson in *Saqqakhaneh*.

24 See Michel Tapié [de Ceyleran], introduction to catalogue of an exhibition of Zenderoudi's works held at Galerie Stadler, Paris, 1971.

25 Siah Armajani, as quoted in Lisa Lyons, "The Poetry Garden by Siah Armajani," *Design Quarterly* 160 (1994): 11.

26 W. J.T. Mitchell, *Picture Theory: Essays on Verbal and Visual Representation* (Chicago: The University of Chicago Press, 1994), pp. 216–17.

27 Ibid., pp. 70–71.

28 For another important discussion of revolutionary posters and their function in the Iranian Revolution, see Annabelle Sreberny-Mohammadi and Ali Mohammadi, *Small Media, Big Revolution: Communication, Culture, and the Iranian Revolution* (Minneapolis: University of Minnesota Press, 1994), pp. 139–62. Peter Chelkowski, "The Art of Revolution and War: The Role of the Graphic Arts in Iran," in this volume, offers important insights into the role of the graphic arts in Iran after 1979. See also Peter Chelkowski and Hamid Dabashi, *Staging a Revolution: the Art of Persuasion in the Islamic Republic of Iran* (London: Booth-Clibborn, 1999).

29 For information on the poster workshop, I am grateful to Nicky Nodjoumi, who maintains a private collection of some of the posters produced by the workshop participants. Islamist students opened their own separate workshop. Islamist posters were also produced in the bazaar.

30 Born in 1935, Momayez graduated from the University of Tehran's School of Fine Arts, where he now teaches. Since the 1950s he has worked as a graphic designer for some of Iran's leading publications. He has been honored for his film posters. Since 1998, he has been Chairman of Iranian Graphic Designers Society (I.G.S.). His work was exhibited in fall 2001 at the Centre Pompidou, Paris, as part of "Le Nouveau Salon de Cent," an international poster exhibition held in tribute to Henri de Toulouse-Lautrec on the anniversary of his death.

31 In an interview with a Persian daily, Momayez discussed modernity and the visual arts in Iran: "It may be said that we have always been able to preserve our national characteristics and keep on with the process of modernism simultaneously." See Reza Jalali, "Historical Background of Graphic Arts in Iran Dates Back to the Medes Era" *Iran*, January 7, 2002; English translation consulted March 24, 2002 <http://www.netiran.com>.

32 For an interesting discussion on social documentary photography, see Peter Hamilton, "Representing the Social: France and Frenchness in Post-war Humanist Photography," in *Representation: Cultural Representations and Signifying Practices*, ed. Stuart Hall (London: Sage, 1997), pp. 75–150.

33 See Shiva Balaghi, "Writing with Light: Abbas's Photographs of the Iranian Revolution of 1979," in this volume.

34 Interview with the author in Paris, March 6, 2001.

ANOTHER MODERNISM: AN IRANIAN PERSPECTIVE

by Fereshteh Daftari

O N A WORLD TOUR IN 1960, Abby Weed Grey of Minnesota arrived in Iran in time to visit the Second Tehran Biennial.[1] Over the next thirteen years she built a collection that would make her the single most important foreign collector of Iranian modern art. This art remains practically unknown in America, and to tell its full story would require a more encyclopedic forum than this publication can provide. The Grey Collection focuses mostly on the 1960s, making it a fairly specialized interest in a field where even generalists are rare. For that matter, modern art of non-Western origin, from virtually any period, has attracted almost no attention in the West until very recently. So perhaps we should begin by simply asking what made Iranian art modern?

Since my point of departure is based on a private collection, it will necessarily omit many accomplished artists. What I shall attempt here is to examine the notion of modernism as an innocent concept, using as my lens the vision of a few artists who were most active in defining it. The aim is to gain a better understanding of modernism's struggles, temptations, contradictions, creative misreadings, and even failures, but also of its triumphs. In shedding the values that have led to a complete disregard of modern art outside the Western hemisphere, we must look out for internalized versions of those values, which, mired in self-contempt, perceive an entire history as a

mimicry devoid of consciousness, with no internal causes and few thoughtful results.

The pendulum to and away from the West begins to swing in late Safavid Persia, in the seventeenth century, and continues on through most of the Qajar period (1785–1925). During these years, artists oscillated between a perceptual approach concerned with volume and space, which was identified with European conventions, and the more conceptual or idealized depiction characteristic of local practice.[2] In this Persian tradition, which is only tenuously linked to reality, the artist looks at a promised or imagined land, a world without shadows and gravity. He freely occupies several viewpoints at the same time and paints with a palette perhaps unfamiliar to nature. The figures, often generic in age, gender, or social class, inhabit paper-thin bodies and space—their otherworldly existence is two-dimensional. Where such tendency towards abstraction was the norm, the mastery of three-dimensional reality came to hold greater fascination than the furthering of the logic of abstraction. As Europeans were discovering the variety of spatial articulations seen in Japanese prints, African art, and Persian miniatures, the non-Western world from Africa to the Far East was poring over perspectival laws and modeling with light and shadow.

In Iran a step toward modernism meant sober observation. Thus, the revered painter Mohammad Ghaffari, better known as Kamal al-Molk (1848?–1940) stands out as one of the first artists to turn away decisively from the Persian tradition and fully explore ideas that had been tentatively and intermittently adapted since the Safavid period. Kamal al-Molk anchored his vision in his surroundings.[3] His first major painting is *The Hall of Mirrors* (1895–96), [Fig. 9] which he executed over a five-year period while serving as court painter to the Qajar king Nasir al-Din Shah. The picture hovers between different modes of representation. Its architectural structure, notably the heavily tilted ceiling, does not bow to perspectival laws. This will to pack in more than allowed by a single viewpoint lingers on from traditional painting. So does the obsessive decoration, which, however, speaks at the same time of a photographic skill in scanning the world and recording its every facet. Kamal al-Molk produced *The Hall of Mirrors* directly on-site, but he also often painted from daguerreotypes—the medium was introduced in Iran soon after its invention in 1839.[4] The artist had learned to harness his vision to a documented reality. While continuing to honor the pomp and splendor of the court, the painting turns the page on the timeless idealizations of authority seen in traditional royal portraiture: its meticulous descrip-

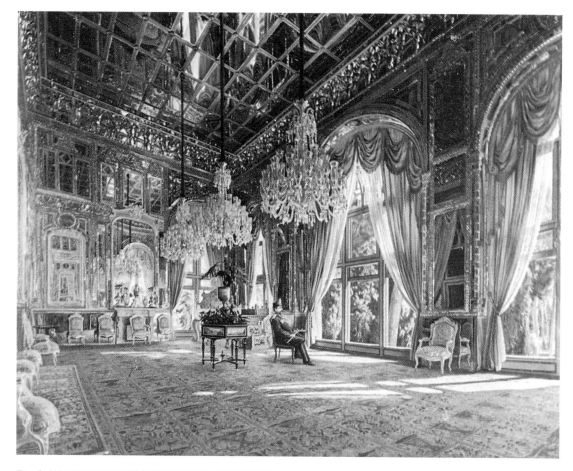

Fig. 9. KAMAL AL-MOLK (MOHAMMAD GHAFFARI).
The Hall of Mirrors. 1895–96 (Dated A.H. 1313).
Oil on canvas.
35 ½ x 39 ⅜ in. (90 x 100 cm).

tion of a specific time and place diminishes the monarch's physical, tempo-
ral, and even political stature. Siding with aesthetic change, Kamal al-Molk's
realism betrays his politically liberal inclinations.[5]

 Nasir al-Din Shah was assassinated on May 1, 1896. Kamal al-Molk
disliked the king's son and successor, Mozaffar al-Din Shah, and a year and a
half later he left on a journey to Europe that continued at least until 1900,
when the Shah visited Paris. There, Kamal al-Molk extended the practice of
recording from direct observation which he had initiated in Tehran; now,
however, his subjects were Old Master and other Western paintings he could

see in the original. His selections ranged from Raphael, Titian, and Rembrandt, to Henri Fantin-Latour (1836–1904).[6] At first, Fantin-Latour had remained independent of both "imperial academicism and insurgent Impressionists."[7] By the end of the 1890s he was moving away from naturalism toward imaginative inventions, but he was not viewed as a full-fledged symbolist. Perhaps Kamal al-Molk found in Fantin-Latour a model of detachment from contemporary movements.

Kamal al-Molk's preference for European Old Masters over contemporary art should not come as a surprise: when Western artists looked to other countries, they too were mostly interested in traditional styles. If Matisse could look at a sixteenth-century Persian miniature and closely assimilate as well as quote its formulas yet not be considered retrograde, why should we blame Kamal al-Molk for his fascination with Rembrandt's portraiture?

An important difference, however, is that in dealing with the Old Masters Kamal al-Molk suppressed his own personality, producing replicas that, in the words of Mozaffar al-Din Shah, "verily did not differ from the original."[8] This fascination with verisimilitude—let's call it "manual reproduction"—was ingrained in Iranian culture, including art training; in fact, Kamal al-Molk had already begun to copy Western painting as a student at the Dar al-Fonun, before his European trip.[9] In discovering the originals, however, he was learning to expand his innate inclination for what he called "naturalism."[10] In the process he was undoubtedly wrestling with the challenge of the West, but meeting it on his own terms and those of his training and culture, with its traditional reverence for the copied original. Paradoxically yet logically, in this emulation he found permission to use himself as a model, painting many self-portraits—an anomaly in Persian art.

Last but not least, his legacy included the appropriation of diverse styles. Unlike that of many Western postmodernist artists of the 1980s, his position was not a rejection of originality, but merely his cultural passport. For Kamal al-Molk and his students, the virtually taxonomic pictorial documentation of European artistic achievements became an affirmation of skill, self, and status.[11]

Was Kamal al-Molk retardataire, or was he a radical innovator? [12] The question is not insignificant: through his teaching at Iran's first academy of fine arts, the Madreseh-ye Sanaye'-e Mostazrafeh in Tehran, which he founded in 1911 and directed until 1927, Kamal al-Molk exercised considerable influence, setting the tone for Iranian art during the first half of the twentieth century.[13] He was the epitome of a modern patriotic Iranian, and his approach,

far from anachronistic, was typical at a time when modernity was equated with Europe. The Western tools that Kamal al-Molk adopted were intended to improve the representation of reality. Such surrender to things Western was not only encouraged, it was "proclaimed with intellectual and political pride," writes Ali Mirsepassi.[14] He quotes the extremist view expressed by Hasan Taqizadeh, who in 1920 urged all patriotic Persians to observe "the adaptation and promotion, without condition or reservation, of European civilization, absolute submission to Europe, and the assimilation of the culture, customs, practices, organization, sciences, arts, life and the whole attitude of Europe."[15] As Nikki R. Keddie argues, this mentality was already in place in the nineteenth century, when "the main concern of many Iranian leaders and thinkers came to be catching up with the West. Although they differed somewhat regarding which elements of Western civilization must be adopted in order to do this, nearly all believed that much must be borrowed."[16] To give a notable example, the Iranian constitution, the prized result of the Constitutional Revolution of 1906, was largely based on that of Belgium.

So, too, in art the impulse of turning to the West was viewed neither as unthinking reflex nor capitulation but rather as rooted in a justifiable logic. Esmail Ashtiani, a student of Kamal al-Molk, considers his teacher neither countermodernist nor Western lackey; instead crediting him for having ushered in welcome improvements. "Kamal al-Molk corrected mistakes, eliminated defects," he said, "nature became the model and science the guide. On the whole, during the short period he taught at his school, he brought a revolution in the field of painting, one that relegated traditional styles to the rank of decorative arts."[17]

In a culture where realism remained suppressed, Kamal al-Molk's rejection of unfaithful representations, his insistence on the visible over the imagined, expressed a progressive and reformist intention. The world he explored in his art was not a promised idyll but rather that of his own experience—the landscapes around Tehran, scenes on his journey to Baghdad, the high dignitaries of his time. Avoiding the nonrealist formulas of the Persian canon, he portrayed what he saw as accurately as he could. The twin models that helped him move along were the Old Masters and photography, a double association with the West. His views, maintained at the Madreseh-ye Sanaye'-e Mostazrafeh, were not challenged, we read, until the 1940s.[18] Further studies are needed to elucidate why intense modernization during Reza Shah Pahlavi's rise to power (1921–25) and reign (1925–41) did not leave a deeper impression on the arts.

At Reza Shah's abdication in 1941, he was succeeded by his son Mohammad Reza Shah, who ruled until the Revolution in 1979.[19] The period between 1941 and the 1953 coup that ousted Mohammad Mossadeq, the elected Prime Minister who nationalized the country's oil industry, was an era of unprecedented democracy. The questioning of authority that became possible during these years took the form, in art, of a battle against the followers of Kamal al-Molk, whose legacy had by now turned into a sterile academy. New aesthetic visions, meek at first, later coalesced into an avalanche of expressions. Reza Giorgiani's review in *Sokhan* (a journal focusing on cultural and literary issues) of the 1946 exhibition "Iranian Fine Arts," which was organized in Tehran by the Soviet Cultural Society (VOKS), offers an important testimony to change: we learn that the exhibition, which cast a wide net over the art of the period, included "young artists who have freed themselves from principles of classical art."[20] Giorgiani credits the Honarkadeh, or Fine Arts Academy, which had been founded in 1940, for the propagation of "the principles of modern painting" and locates the source of creativity in imagination rather than in attention to details.[21]

The first director of the Honarkadeh was the Beaux-Arts-trained French architect and archaeologist André Godard.[22] The faculty included Kamal al-Molk students such as Ali Mohammad Heydarian and Fatollah Obbadi,[23] and two French instructors, "Monsieur Roland Dubreuil" in sculpture and "Madame Aminfar," who emphasized knowledge of Western modern art, including plein-air painting.[24] Despite the language barrier between the French instructors and the students—one of the major flaws of this not-quite-Beaux-Arts system—the Kamal al-Molk tradition took a blow from the new pedagogy, which stressed imaginative invention over servile copying.

Among the first graduates of the Academy was Jalil Ziapour (1920–1999), who left in 1946 with a scholarship to study in Paris. Ziapour was to become one of Iran's most influential champions of modernism. In Paris he studied at the École des Beaux-Arts as well as with the Cubist painter André Lhote. Lhote's version of Cubism made a profound impact on the young Ziapour, as did the French artist's theories, interest in decorative arts, and solid humanism. On returning to Tehran in 1948, Ziapour cofounded a society and a periodical called *Fighting Rooster* [Fig.10] as a forum for modernism. The magazine's first issue began, strategically, with "cock-a-doodle-do," the first line of a poem by Nima Yushij (1895–1959), the exemplary voice of the avant-garde in Persian literature.

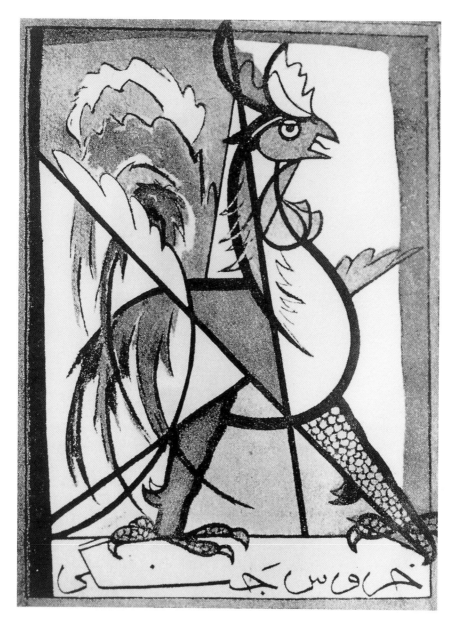

Fig. 10. JALIL ZIAPOUR.
Logo for the periodical *Fighting Rooster*. 1949.
c. 7 ½ x 5 ½ in. (19 x 14 cm).

Why in the late 1940s would an Iranian artist militantly espouse Cubism, a style that had been invented nearly forty years earlier? Cubism was, of course, closely associated with Picasso—who was modernism personified; another part of the answer lies in Ziapour's experience of Paris between 1946 and 1948, when Cubism and Fauvism were both undergoing a revival. In an attempt to erase the humiliation of the German Occupation—and with a good deal of chauvinist fervor—critics, curators, and other interested parties were seeking to reestablish a continuity between French culture and its glorious moments in the prewar period. They turned to the celebration of Cubism as a French tradition.[25] For Ziapour, then, Cubism was tinged with nationalism, and to appropriate it and make it Iranian was a logical proposition. On his return to Tehran, he began to use the language of geometry to articulate an Iranian subject matter; at first this was imagined, such as the scene of women washing in *Public Bath*, and subsequently it derived from his research into tribal customs and costumes.[26] Thus he devised his version of an Iranian Cubism: local in content, Western in form.

There is surely also another answer to our question. What better tool than Cubism to smash, fragment, and shatter the visible world, or rather the conventions for its representation, which had been so highly revered by Kamal al-Molk and his followers for half a century? That such was Ziapour's intention is indicated in the analogy he proposed between Picasso's brushwork and a "machete which trims/prunes the forms and branches of nature."[27] However, Ziapour's rhetoric, not unlike Lhote's, was more vehement than his brush. In a treatise of 1948, for instance, he advocated what he called "specialized painting," basically arguing for the autonomy of art,[28] but an attachment to figuration persisted in his work until very late in his career. Only in his last years did he thoroughly follow through on the implications of his own writings, conflating the Cubist grid with the geometry of tiles to produce an art as abstract as Minimalism yet simultaneously completely Iranian.

We cannot view Ziapour, and other modernists like him, as uncritically admiring of the West. They were not mindless puppets, and had their own targets and strategies. In the Iranian context they were engaged in a conscious fight against the status quo and sought to reconcile the nation-state identity with internationalism.

In the relatively open atmosphere of Iran during the 1940s, private entrepreneurship led to the founding of the first art gallery in Tehran: in September 1949, Mahmud Javadipur (born 1920) and Hossein Kazemi (1924–1996), both artists, along with a third partner, Houshang Ajoudani, founded Apadana, an exhibition space and gathering place for intellectuals that was organized around a weekly *thé dansant,* for which an admission fee of 5 rials was charged. The gallery closed less than a year later, in July 1950.[29] Still, for its brief life, Apadana served as a major venue for modernist tendencies, in particular as a breeding ground for Ziapour's version of Cubism.

Not all Iranian artists left the country, and not all who left returned.[30] Many, like Ziapour, Javadipur, Kazemi, and others who went to Paris, Munich, or Istanbul, where they encountered a range of debates specific to the postwar era, returned home with fragments of foreign vocabularies with which they attempted to express local themes. The great diversity of expression was sometimes reflected within the oeuvre of a single individual. Javadipur, for example, saw the multiplicity of styles in his paintings as a statement of freedom.[31] For him, modernism meant the liberty to pick and choose, to hop from one idiom to another—postmodernism avant-la-lettre.

Beginning in 1954, the tempo accelerated with the activities of the Armenian Iranian Marcos Grigorian (born 1925), who returned that year from Rome, where he had graduated from the Accademia di Belle Arti. In opening his Galerie Esthétique (1954–59),[32] which was more like a Western-style commercial art space than the Apadana had been, and in organizing the first Tehran Biennial in 1958, under the supervision of the Ministry of Culture, Grigorian was a functioning art impresario.[33] He provided exhibition space for much of the modernist art seen in Tehran in the second half of the 1950s. As a gallery-owner and curator, he was also among the first to recognize and pay serious attention to a form of popular art, naively painted and inspired by religion and literature, commonly known as *qahveh khaneh,* or coffee-house painting, after one of the locations where they were displayed.[34]

Grigorian was also an influential teacher at the Honarestan-e Honarha-ye Ziba. He encouraged personal visions, taught printing techniques such as linocut, and disseminated his enthusiasm for expressions of local popular culture. Above all, he was a staunch adversary of the traditionalists, be they miniature painters or followers of Kamal al-Molk. On the other hand, however, he did not favor Cubism. Farhang Farahi, writing in the Galerie Esthétique's publication, presumably echoes Grigorian's views when he writes "one must be of one's time," that the nation should have its own

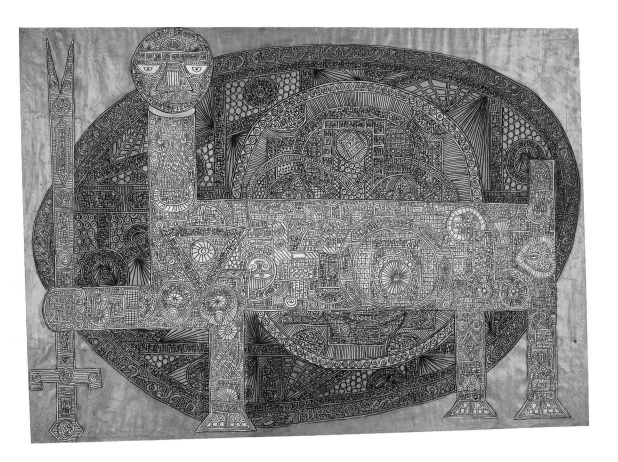

Fig. 11. HOSSEIN ZENDEROUDI.
The Sun and the Lion. 1960.
Ink, watercolor, and gold paint on paper.
42 x 58 in. (106.7 x 147.3 cm).

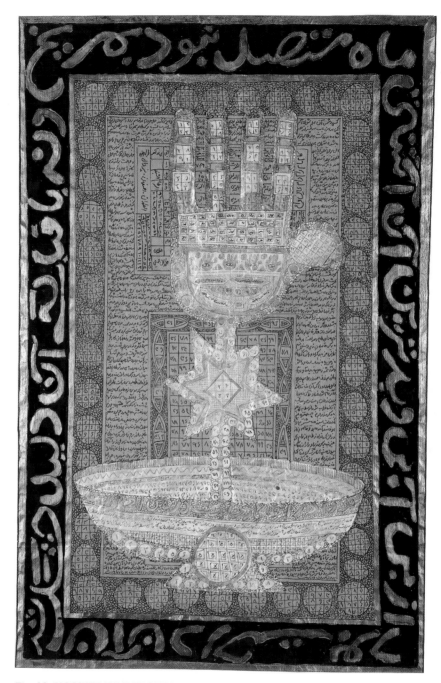

Fig. 12. HOSSEIN ZENDEROUDI.
The Hand. c. 1960.
Paper collage with ink, watercolor, and gold and silver paint.
26 ³/₄ x 17 ¹/₂ in. (67.9 x 44.5 cm).

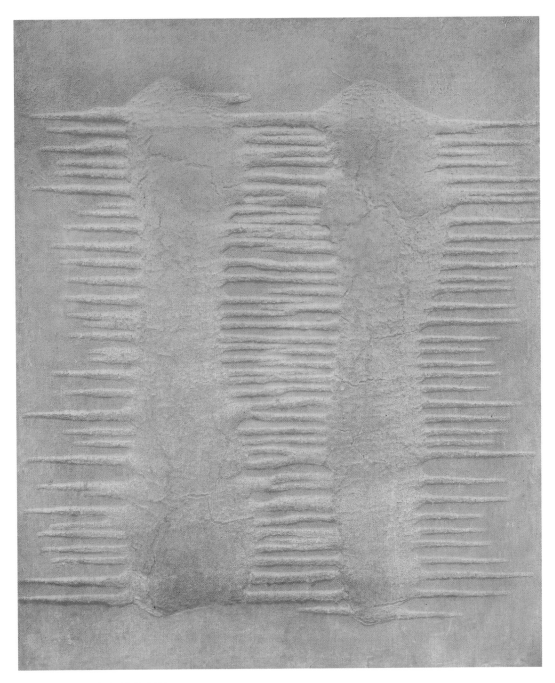

Fig. 13. MARCOS GRIGORIAN.
Untitled. 1963.
Sand and enamel on canvas.
30 x 25 in. (76.2 x 63.5 cm).

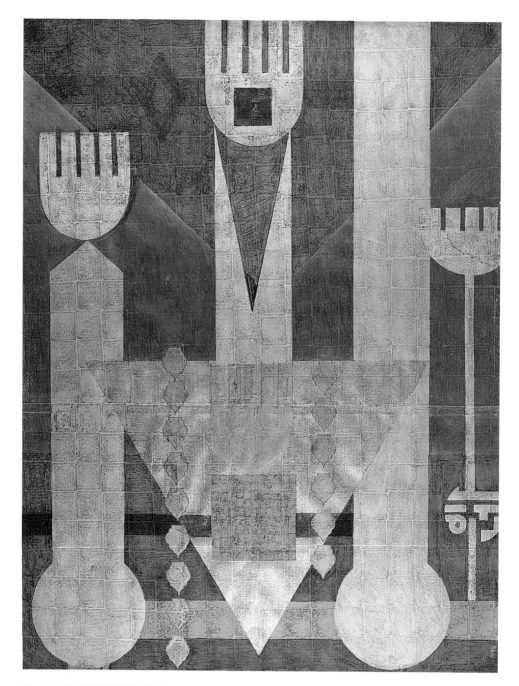

Fig. 14. FARAMARZ PILARAM.
Mosques of Isfahan. c. 1962.
Watercolor and gold and silver paint.
45 ¾ x 34 ¾ in. (116.2 x 88.3 cm).

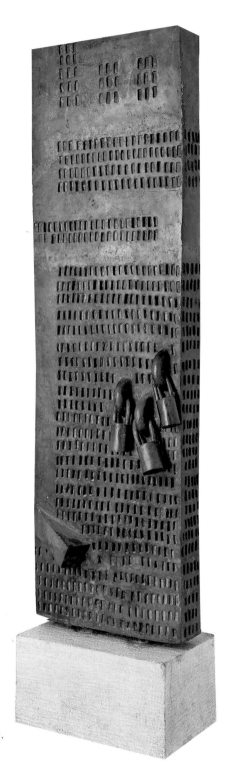

Fig. 15. PARVIZ TANAVOLI.
Heech Tablet. 1973.
Bronze on travertine base.
71 ¹/₂ x 18 ¹/₂ x 11 ⁷/₈ in. (181.6 x 47 x 30.2 cm),
including base.

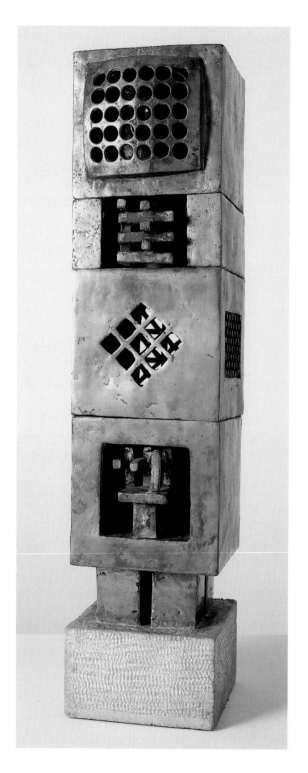

Fig. 16. PARVIZ TANAVOLI.
We Are Happy Locked Within Holes. 1970.
Bronze on travertine base. 30 x 7 ¼ x 10 ¾ in.
(76.2 x 18.4 x 27.3 cm), including base.

OPPOSITE Fig. 17. SIAH ARMAJANI.
Prayer for the Sun. 1962.
Oil on canvas.
48 ¼ x 32 in. (122.6 x 81.3 cm).

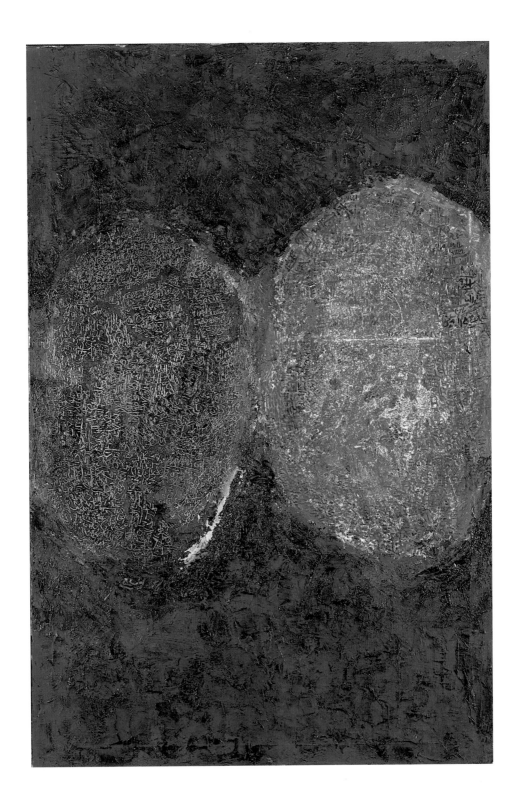

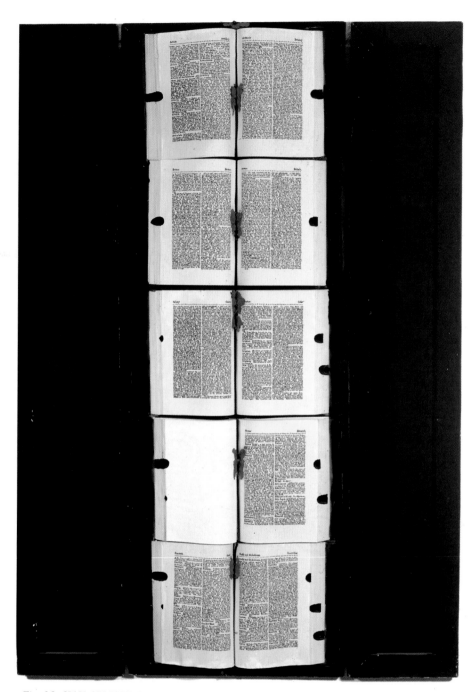

Fig. 18. SIAH ARMAJANI.
Warren Report. 1965.
Books, wood, ribbon, and wax.
44 ³/₄ x 16 ¹/₂ x 4 ¹/₂ in. (113.7 x 41.9 x 11.4 cm).

Fig. 19. MONIR SHAHROUDY FARMANFARMAIAN.
Eight Times Eight. c. 1975.
Mirror, stainless steel, and paint.
51 x 51 in. (129.5 x 129.5 cm).

Fig. 20. BEHJAT SADR.
Abstract IV. 1961.
Oil on paper.
13 ½ x 18 ¼ in. (34.6 x 46.4 cm).

Fig. 21. SOHRAB SEPEHRI.
Trees. 1970.
Oil on burlap.
32 x 40 in. (81.3 x 101.6 cm).

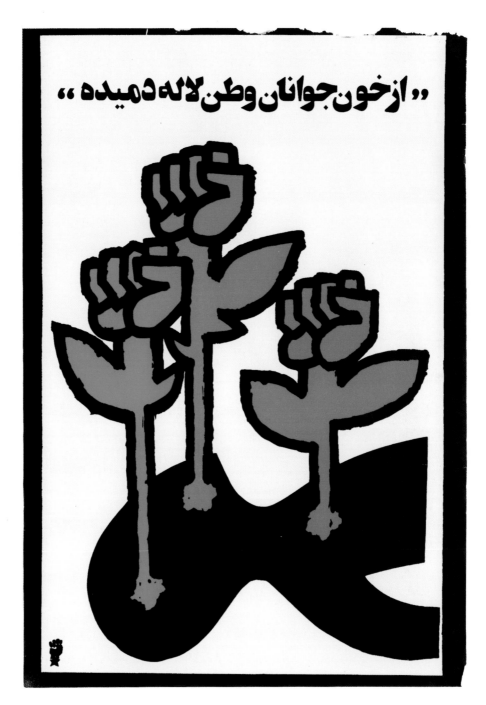

Fig. 22. MORTEZA MOMAYEZ.
Poster depicting fists as tulips. c. 1978–79.
19 x 13 in. (48.3 x 33 cm).

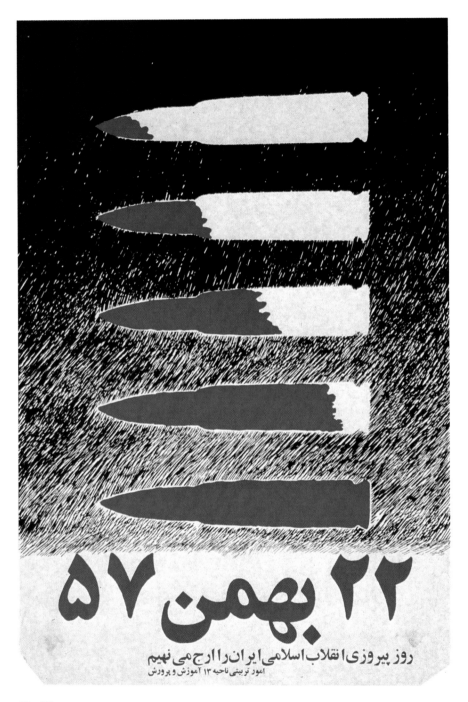

Fig. 23.
Poster of bullets. c. 1979–88.
28 x 19 in. (71.1 x 48.3 cm).

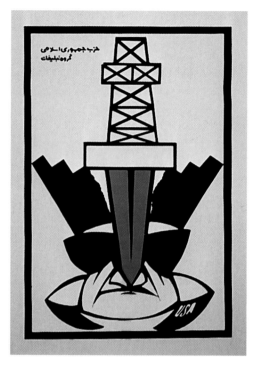

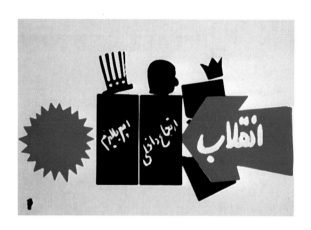

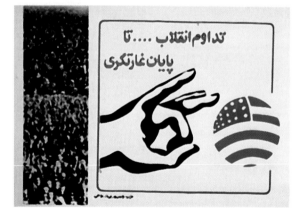

ABOVE Fig. 24. ARAPIK BAGHDASARIAN.
Poster with a dagger in the form of an oil rig.
c. 1979–88.
28 x 20 in. (71.1 x 50.8 cm).

ABOVE LEFT Fig. 25.
Poster with red arrow and sun. c. 1980–88.
14 x 19 in. (35.6 x 22.9 cm).

LEFT Fig. 26.
Poster of a hand and a sphere. c. 1980–88.
14 x 20 in. (35.6 x 50.8 cm).

OPPOSITE TOP Fig. 27.
Poster of Zeinab. 1979.
28 x 20 in. (71.1 x 50.8 cm).

OPPOSITE BELOW Fig. 28.
Poster with a clenched fist. 1980.
31 x 24 in. (78.7 x 61.2 cm).

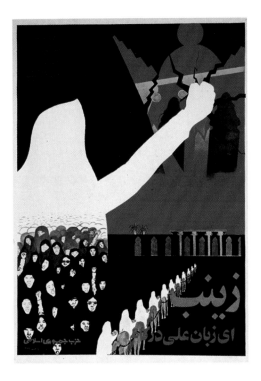

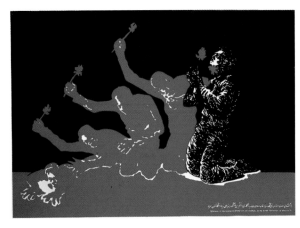

BELOW Fig. 29.
Poster celebrating the reopening of the Hosseiniyyeh-e
Ershdad seminary. 1979.
20 x 28 in. (50.8 x 71.1 cm).

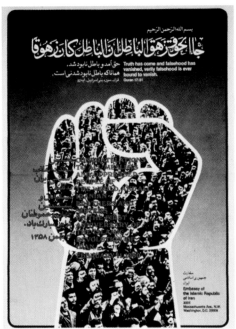

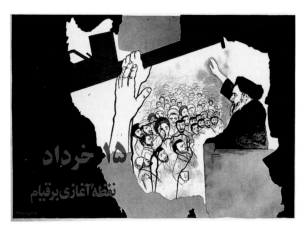

ABOVE Fig. 30.
Poster of Ayatollah Khomeini preaching. 1979.
20 x 28 in. (50.8 x 71.1 cm).

Fig. 31.
Poster of Ayatollah Khomeini. c. 1980–85.
12 x 11 in. (32.5 x 27.9 cm).

visual language, and that "Cubism or any other Western style cannot develop widely in our country because they lack authenticity."[35] Grigorian's own trajectory reflects that search for an expression that is modern but not borrowed. By 1960 the intense expressionism he had imported into his own work from his years in Italy, exemplified in his twelve-panel painting *Gate of Auschwitz* (1959–60), was dissolving in favor of the very stuff of the Iranian desert: parched earth and mud. With these humble materials the entire grand tradition of painting, traditionalist and modernist alike, crumbles into dust. [Fig. 13] According to Grigorian, the soil and ash he applied to the final panel of his painting, which depicts Nazi atrocities, constituted his first use of nontraditional substances. Should one seek precedents for this in the thick crust of Jean Dubuffet's post-Holocaust paintings? Was Grigorian's mixture of sand, earth, and straw itself a precursor to Anselm Kiefer's 1980s depictions of the German mindscape? It seems more important to note that Grigorian was an artist of his time. In a climate when the relationship of the language of art to the national culture was provoking heated debate, he discovered a pertinent solution. If critics were condemning the rise of an abstraction lacking local roots,[36] Grigorian's abstraction was born out of the Iranian land—a medium speaking for a culture.

The aesthetic arguments involved more than a preference for figuration or for abstraction, this "ism" or that. They reflected a national dilemma: how to preserve an Iranian identity, termed "authentic," that was threatened by near-abdication to the omnipresent West, without retreating into xenophobic parochialism or renouncing the aspiration to be modern. Modernization and Westernization had long been a project to which Reza Shah Pahlavi was committed as a matter of national pride. As Gavin Hambly writes, "Until Iran came to resemble a European nation-state, it would not be treated like one."[37] Mohammad Reza Shah, once in full control after 1953, intensified this process to the point where, by 1962, Jalal Al-e Ahmad (1923–1969) was referring to the phenomenon as *gharbzadegi*, variously translated as "weststruckness," "occidentosis," and "westoxication," and in any case a condition indicating fascination but above all disease.[38] Al-e Ahmad's book of the same title was not openly distributed until 1978. Its author, an intellectual from a religious background, had moved through various ideologies before settling into a critique of Westernization and a call for a return to local Islamic roots. His version of cultural authenticity, it has been argued, was "neither local nor authentic [but] grounded in some construction of the local."[39]

Fig. 32. HOSSEIN ZENDEROUDI.
K+L+32+H+4. 1962.
Felt pen and colored ink on paper mounted on composition board.
89 x 58 ⅝ in. (226 x 148.9 cm).

Also in 1962, similar if not identical sentiments find expression in a harsh criticism of the third Tehran Biennial. Deploring the prevalent abstraction as of Western origin, Cyrus Zoka insisted that "our account is separate from the West. No copy is better than the original."[40] He likened the situation to wearing a turban with jeans while dancing the twist. For Zoka, modernism had meaning only if it was manifested in every area of culture and society—if it was not arbitrarily selective, but rather an across-the-board phenomenon. He called for a visual language that would speak specifically to Iranians.

Within the cacophony of foreign speech, however, Zoka detected a "familiar message" in the work of a young painter who seemed to be "searching for the key to our unspoken secrets."[41] The artist was Hossein Zenderoudi (b. 1937), the work *K+L+32+H+4*, 1962. [Fig. 32] Executed in Paris, it was first shown at the Tehran Biennial and then at the Venice Biennale, where Alfred H. Barr Jr. acquired it for the Museum of Modern Art, New York.[42] A look at the works preceding this painting is helpful in understanding the direction of Iran's modernist tide.

While he was still in art school in Tehran, Zenderoudi had already tackled a diverse range of primitivizing tendencies. The kind he had learned from his Beaux-Arts-trained teacher Shokouh Riazi (1921–1962)[43] is exemplified in the undated, Modigliani-esque portrait that he exhibited at the 1960 Tehran Biennial.[44] One of his undated drawings in the Grey collection speaks almost in the voice of outsider art. Let us recall that Zenderoudi had also found compelling inspiration in the local primitivism of the coffee-house paintings. His teacher Grigorian was one of the first champions of the genre, having sought out two contemporary practitioners, Qolar Aghassi and Mohammad Modabber. [Fig. 33] Grigorian had commissioned paintings from them, shown their work at the Galerie Esthétique, written about them, and encouraged his students to adopt them as models.[45] In a time of thirst for Western sophistication, these local, marginalized expressions had been neglected as undesirable facets of Iranian identity. Zenderoudi capitalized on Grigorian's rescue mission. Soon Queen Farah Pahlavi was forming a collection of coffee-house paintings, which she eventually donated to the Negarestan Museum.

Absorbing the religious themes narrated by these untutored painters, Zenderoudi produced his own version, chronicling the martyrdom of Imam Hossein in 680, an event known as the Karbala tragedy, passion, or paradigm.

Fig. 33. Attributed to MOHAMMAD MODABBER.
The Life of Ibn Muslim. c. 1950s.
Oil on canvas.
41 ³/₄ x 71 ¹/₄ in. (106 x 181 cm).

[Fig. 34] Pushing stylization even further than the coffee-house painters had, Zenderoudi carved the compartmentalized scene of each episode into linoleum, then printed the ensemble—using the linocut technique he had learned in Grigorian's class sometime between 1958 and 1960.[46] Only two complete *pardeh*, or printed fabric panels, are believed to have been made; they were both purchased in 1960.[47] The Grey collection includes two linocuts on paper of individual episodes, each entitled *A View of Islam*. In the border of each panel there appears a punning phrase typical of Zenderoudi's mischievous humor: writing "Who is this Hossein the world is crazy about?" he refers both to the Imam and to himself. Marginal in these early prints, calligraphy would take center stage in his work by 1963.

Zenderoudi embodies the "authentic local" with whom begins a movement away from Western idioms and back into the depths of Shiite iconography, articulated in terms not of the miniature tradition, say, but rather of the local vernacular. He chose cheap paper as his support and ordi-

nary disposable pens as his medium. The sources of his imagery include not only sacred calligraphy, but also posters and folk art. Zenderoudi takes us to southern Tehran, away from the affluent neighborhoods to the north. Sensitized to the possibilities of a renewed Islamic vocabulary, he scavenged the bazaar for popular prints, amulets, apotropaic charms, talismanic artifacts, astrolabes, props used in mourning processions, carved and printed prayers, zodiac signs, and more.[48]

In Tehran, Zenderoudi also frequented the Iran Bastan Museum, where he saw a cloak or robe that was to have profound repercussions in his

Fig. 34. Detail from HOSSEIN ZENDEROUDI.
Who Is This Hossein the World Is Crazy About? 1960.
Linocut on fabric.

work. [Fig. 35] Ornamented with protective prayers, talismanic messages, and numerological tables, the robe fed Zenderoudi's imagination, its silhouette mutating into the headless body and maimed limbs of Shiite martyrs. (In Zenderoudi's art the human body always appears as a mediated surrogate.) The robe, soiled with expressionist blood, had already filtered into his work by the Spring of 1961, when he exhibited at the Atelier Kaboud, the studio of the sculptor Parviz Tanavoli.[49] At the Paris Biennial that fall, Zenderoudi exhibited five works made in 1960 and 1961; the body in *4-A-36L* (inscribed 1961), again in robe-like form, is geometricized, mutilated, severed in two, and entirely tattooed with ornamentation. [Fig. 36] By the time he arrived at the work of 1962 that is now in the collection of the Museum of Modern Art,

Fig. 35. Detail of shirt with Koranic verses and prayers. Isfahan. c. 16th century. Fabric.
34 ³/₄ x 32 ¹/₄ in. (88 x 82 cm).

Fig. 36. HOSSEIN ZENDEROUDI.
4-A-36L. 1961.

Ink and watercolor on paper mounted on canvas.

69 ⁵/₈ x 23 ³/₈ in. (177 x 72 cm).

Zenderoudi had established a fully developed syntax brewing a private mythology out of religion, superstition, augury, numerology, divination, and coded signs. *K+L+32+H+4* is his cryptic confession. Islamic in appearance, the narrative is highly veiled and personal; the real subject, he says, is "My father and myself."[50] On the left, the artist raises his arms, head hanging low. His body, prison of the soul, is drawn rigidly as if confined in a straitjacket. On the right, a constellation crowns the composite image of his father. In this work Zenderoudi fuses his genealogy, combining his physical and his spiritual heritage. Mechanomorphic in articulation and fashioned with a craftsmanship reminiscent of Islamic metalwork, the surface is richly filled—space has been sucked away. Astrology, religion, and personal history are enmeshed in this personalized universe. The crammed surface leaves no room for Western ideology.

Zenderoudi's renewal of Islamic symbolism, making it viable for the contemporary world, recalls Al-e Ahmad's attempt to reconcile religion and modernity. With Zenderoudi, however, religion is neither militant nor overtly spiritual or contemplative. Rather, it remains hermetic, and often as indecipherable as a private code. Yet his modernism, rooted in the revival of an anti-perspectival tradition, inbred and not transplanted, provided an answer to the problem critics had been debating: this was the hoped-for Iranian voice.

The official reaction was positive. "Wherever Iranian art is now to be represented, prominence is given to the contributions of the new school," wrote the prominent critic Karim Emami.[51] By the mid-1960s Queen Farah Pahlavi, who had married the Shah in December 1959, had offered her full support. Her policies, implemented in the annual Shiraz Festival (1967–77) and the museums she created, merit a separate study, but what matters for our purposes here is that in a process of identity construction she was just as committed to safeguarding the cultural patrimony as to exposing Iranians to the latest waves of Western expression. The Queen and her cousin Kamran Diba (born 1937)—artist, architect, and first director of the Tehran Museum of Contemporary Art (inaugurated in October 1977), which he designed—were among the most enthusiastic local collectors of Iranian and Western modern art.[52]

Within the internal debate on the relative merits of tradition versus modernity, the paradigm shift effected by Zenderoudi had tremendous resonance. Tools of expression need no longer be imported, the work seemed to say; they could be excavated locally. Thus the incompatibility between tradi-

tion and modernity was rendered invalid: a path was suggested toward a modernity that was not opposed to an identity grounded in local popular traditions. The major departure from earlier modernist works—such as Sirak Melkonian's *Veiled Women,* the prizewinning painting in the 1958 Tehran Biennial—lay not only in the representation of indigenous subject matter but also in the expression of a vernacular culture with its own visual means and lexicon.[53] Zenderoudi seemed to satisfy the thirst for a national modern art. In June 1963 Karim Emami, reviewing a one-day exhibition at the Gilgamesh Gallery of works by artists chosen to be sent abroad, compared Zenderoudi's "raw materials" to objects found in a "*saqqakhaneh* in old Tehran."[54] The term caught on, and a movement was coined.

A *saqqakhaneh* is a ceremonial public structure holding water for thirsty passers-by. It is constructed in memory of the seventh-century Shiite martyrs who were denied access to water in the heat of the Karbala plain. Exterior and interior decoration of these structures—which are often located in bazaars—may range from a simple brass hand [Fig. 37] (symbolizing the

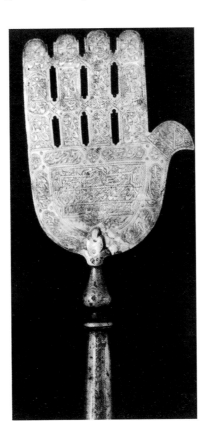

Fig. 37. *Hand.*
19th century.
Brass.
18 in. (46 cm) high.

severed hand of Hazrat Abbas, who attempted to bring back water from the Euphrates) and a drinking bowl to religious prints and objects such as pad-locks or pieces of cloth knotted around the grillwork in acts of private devo-tion. In addition to functioning as a fountain, the whole complex constitutes a kind of mnemonic installation, a quotidian affirmation of faith, an inter-mediary between believers and their aspirations. Emami recognized some of these signs and symbols in the new art.[55] [Fig. 12]

Immediately a host of artists, all born in the 1930s, who were adapt-ing motifs and themes from the Iranian past—even when unrelated to Shiite iconography, from the Achaemenids to the Qajars—were branded as mem-bers of the "Saqqakhaneh school."[56] This was not an official association, with stated goals or a manifesto, and the imagery and vocabulary of its practition-ers vary from artist to artist. Mansoor Ghandriz (1935–1965) graphically articulated mythic creatures; Faramarz Pilaram (1938–1983) produced hybrid forms merging architectural and body fragments, namely minarets and the severed hands of Hazrat Abbas. [Fig. 38] Both these artists preferred iconic frontality. Nasser Ovissi (born 1934) and Sadegh Tabrizi (born 1938) remained attached to the horseback riders and lyrical couples populating Persian miniatures and ceramics. Massoud Arabshahi (born 1935) gravitated towards pre-Islamic symbolism. Playing central roles in the work of most of these painters are the twin notions of beauty and decoration, which in Western modernism are viewed with a certain suspicion and condemned to exile.

In sculpture, Jazeh Tabatabai (born 1930) welded found objects into grotesque, composite, robotic creatures that transformed his fears of war, and his aversion to all things military, into innocuous toys.[57] Also a painter, he was often inspired by folk art. His ironic frame of mind and persistent satir-ical streak distinguish him from the other artists in the group. Parviz Tanavoli (born 1937), who was Zenderoudi's accomplice in the Saqqakhaneh venture, emerged as a fervent believer in a modernism attained through forms of pop-ular visual culture. He was and remains a creative collector, always insight-ful, whether he is looking at "old tools and underappreciated rugs" or at Zenderoudi's innovative transformations of popular sources.[58] Proud of hav-ing opened his studio, the Atelier Kaboud, to Zenderoudi—who exhibited there at least twice, in May and October 1961—Tanavoli considers it the cra-dle of the Saqqakhaneh movement.[59]

Having traveled to Italy as a young art student, Tanavoli returned to Tehran in 1960. At that time the Iranian art scene was dominated by paint-

Fig. 38. FARAMARZ PILARAM.
Mosques of Isfahan. c. 1962.
Watercolor and gold and silver paint.
45 ³/₄ x 34 ³/₄ in. (116.2 x 88.3 cm).

ing, leaving him, a sculptor, with no burden of tradition to reckon with, and a great deal of freedom. The vacuum, significant in that it reflected a fear of idolatry, could not be filled with the kind of Western figurative tradition to which Tanavoli had been exposed in Italy. The mannered figuration of sculptures by Emilio Greco, which he saw in Carrara in 1956–57,[60] and Marino Marini, with whom he studied in Milan, could not have been fruitfully extended and did not resonate with him for long. However, these sculptors, rooted in Etruscan and Roman art, may well have inspired Tanavoli to look to his own cultural heritage. While remaining faithful to their anthropocentric vision, he resorted to inanimate objects as surrogates for the figure.

With no significant tradition to build on, Tanavoli sought a lineage in mythology. He claimed his sculptural ancestor in Farhad, who, according to legend, carved mountains for the love of Shirin. For visual inspiration Tanavoli reached all the way back to the pre-Islamic era and deep into the neglected domains of contemporary tools and artisanal objects. Building his works incrementally, whether vertically or horizontally, he developed a vocabulary of welded faucets, tubes, knobs, grillwork, and the keys and locks he collected in small towns and local bazaars. Fused together, these agglomerations ultimately yield the image of a gendered figure or a generic couple, primitive and regal. [Fig. 39] Neither inhabitants of the unconscious, as in the work of Max Ernst, nor warriors of the machine age, these creatures belong to a preindustrial era. Flaunting references to literature and religion, they stand as metaphors for a developing nation that is materially hampered but spiritually proud.

Fig. 39. PARVIZ TANAVOLI.
Bronze Prophet. 1963.
Bronze.
39 ½ x 15 x 7 ½ in. (100.3 x 38.1 x 19.1 cm).

Like ancient Persian and Mesopotamian sculpture, such as the Babylonian Hammurabi stelae at the Louvre (of which there is a replica in the Iran Bastan Museum in Tehran), Tanavoli's works are designed to be viewed from the front or the back rather than in the round. In *Heech Tablet*, 1973, [Fig. 15] the surface markings parody cuneiform inscriptions, which predate the script inherited by Iranians after the Arab invasion in the seventh century. They also recall the grillwork protecting both the *saqqakhaneh* and the *imamzadeh* (shrine dedicated to an Imam's descendant) religious structures. Here ancient pre-Islamic inscriptions and the aura of Islamic religion are locked together in the expression of a continuous, undivided past. The senseless text, reinforced by the title—"heech" means "nothing" in Persian—betrays either an ambivalence towards that history or perhaps disillusionment with an insignificant present. Other works, such as *We Are Happy Locked Within Holes*, [Fig. 16] evoke a cage or prison tower and invite the viewer to look beyond the surface into confined spaces where sexuality and love clandestinely survive, in the form of a phallus in one cell and interlaced hands in another. It is as if Giacometti's cages merged with, say, a Zoroastrian fire temple—such as the square structure at Naqsh-e Rostam, near Persepolis, from the sixth or fifth century B.C.—to form a hybrid language that converts a prison into a temple of love.

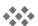

Both Tanavoli and Abby Grey have told the story of their meeting in Tehran in 1961, and of how it resulted in a teaching position for Tanavoli in Minneapolis, where he arrived in 1963.[61] In turn, Grey initiated a meeting between Tanavoli and Siah Armajani (born 1939), who had emigrated to the United States from Iran in 1960. Both artists came from a background where sculpture was practically absent but architecture considered a great achievement. Eventually both, each in his own way, would produce hybrids of the two forms, Armajani creating actual spaces for communal interaction, Tanavoli making works with enclosed units derived from architecture. The Grey collection lacks examples of Armajani's architectural installations but does include his early and less-known calligraphic work, which not only prefigures his later interest in art as means of communication, but also can be seen to evolve from traditional craft to conceptual expression.

Before leaving Iran, Armajani began practicing calligraphy as early as 1956.[62] He continued to do so in America. In 1962, as a student of philosophy, he scratched and buried illegible words within two barely touching celestial bodies in the nocturnal *Prayer for the Sun*. [Fig. 17] That same year, as in a hushed prayer, repeated, soundless, and incomprehensible, he covered the surface of a painting with inscriptions.[63] The minuteness of the marks in this work is suggestive of distance; *Calligraphy*, 1964, [Fig. 7] in the Grey Collection reworks it through a kind of aerial perspective. Soon after he made these two works, Armajani began to treat writing as a ready-made image to be copied. In 1965 he traced over the printed text of the *Warren Report* [Fig. 18] by hand, reenacting an investigation that was itself an account of a series of assassinations. The next step was *Print Apple 2*, 1967, in which the artist's hand withdraws and the computer takes over. In Armajani's work, text evolves from calligraphy, an aestheticized means of communication, to its "assassination" through rote repetition—from craft to concept—and finally to computer-printed matter.

Calligraphy, however, would become the signature style of Zenderoudi, who developed this Islamic expression abroad (he has lived in Paris and Meaux since 1961).[64] In contrast to the anti-retinal, text-based conceptual art of the 1960s by Americans such as Joseph Kosuth and John Baldessari, but more in tune with the Lettristes he met in Paris, Zenderoudi's work affirms visuality and explores the formal possibilities of the written word. A quintessential cipher of Islamic tradition becomes the vocal cord of Iranian modernism. Shedding its traditional limited-format ink-and-paper materials, it migrates into the vast oil-on-canvas arena of Western art. (Pilaram also joined the new direction, along with calligraphers-turned-painters such as Reza Mafi.) With strokes now expansive and free-floating, now clustered in regimented alignments, now statically stamped, now at play in a field activated by optical illusion, Zenderoudi moves from one style into another, from allover expressionism to lean minimalism and anything in between. [Fig. 40] He navigates back and forth through the millennia, from cuneiform to Arabic script, and through cultures, both indigenous and foreign. Divorcing text from meaning, from literature, from religion, from language itself, he turns word into image and function into form.

Pure abstraction, the alleged territory of Western modernism, did not escape Iranian artists. Its expression in the works of two women artists represented in the Grey Collection reveals that it, too, can be linked to different cultures. Trained in the 1940s at Cornell University as well as at

Fig. 40. HOSSEIN ZENDEROUDI.
Untitled. 1968.
Oil on canvas.
76 ³/₄ x 51¹/₈ in. (195 x 130cm).

Parsons School of Design and the Art Students League in New York City, Monir Shahroudy Farmanfarmaian firmly grounded her work in the geometry of Islamic art. Her abstract *Eight Times Eight* was conceived by the artist and executed under her supervision, by master craftsmen, in glass, steel, and cut mirror—materials often used in the decoration of palaces, such as the Qajar Hall of Mirrors depicted by Kamal al-Molk. [Fig. 19] The artist's direct source of inspiration, however, was not a palace but the Shah Cheragh shrine in Shiraz. In Farmanfarmaian's art, commitment to beauty, craft, and ornamentation—all quintessentially Persian but unacceptable elements in the Western avant-garde—are welded to a non-Iranian conceptual approach in which the artist does not fabricate a work but rather orchestrates its execution. In the process she blurs the boundary between conceptual art and craftsmanship, painting and sculpture, and turns ornamentation into art.

Both the advent of Pattern Painting in the 1970s and more recently the exoneration of the concept of beauty (which is greatly indebted to Dave Hickey's essays) allow for a more positive assessment of works such as Farmanfarmaian's, which renew one's faith in visual pleasure.[65] Thus, the sumptuous glitter of her work belongs as much to Iranian modernism as to the current resurrection of beauty.

Behjat Sadr's (born 1924) early abstractions take a different route: their journey originates in Europe, where she went to study—at the Accademia di Belle Arti, first in Rome and then in Naples, where she received a degree in 1957. Executed with a palette knife, her paintings trace the ebb and flow of gestural movements in a vein similar to that of formal explorations practiced in the West. [Fig. 20] After the Revolution and her emigration to Paris, however, Sadr's abstract strokes receded to the periphery, where they served to frame a central image—often a photograph of a place, whether a site she left behind or a desolate view of the River Seine into which she would often stare. In a later work, a collage, Sadr evokes a rupture that split her reality, and by implication Iranian modern history, into separate zones: before and after the Revolution. [Fig. 41]

The activities that constituted what has been termed Iranian modernism were a welling tide of diverse expressions, sometimes transplanted, other times homegrown. Within this pluralism, we looked into the escapes from tradition, noted the conversions to Western models, and marked the reconciliations with local culture. A few diverged from these options. An artist such as Sohrab Sepheri (1928–1980), painter and poet, took a solitary path. From his native Kashan, a small town situated on the edge of the desert that

Fig. 41. BEHJAT SADR.
Untitled. 1982.
Collage of chromogenic print and oil on paper.
27 ¹/₂ x 58 ⁵/₈ in. (70 x 100 cm).

lent its colors to his palette, he took a detour via the Far East. Succinct, direct,
and assertive, his brushstrokes telegraphically convey the presence of trees in
an arid landscape. [Fig. 21] Esmail Tavakoli, better known as Masht Esmail
(1923–2000?), the untutored janitor of a sculpture workshop, simply
remained oblivious to all debates and partisan views. [Fig. 42] Most Iranian
modernists, however, stayed locked in a dysfunctional relation with the
West. Some drowned under its influence, many compromised, a few tri-
umphed, but all endeavored to articulate solutions to vital questions: How to
be Persian and modern? Which direction to take: the West or the past, or
both? This other modernism, like many of the culturally specific modernisms
that emerged around the globe, was neither synchronous nor synonymous

Fig. 42. ESMAIL TAVAKOLI (MASHT ESMAIL).
The Goat. 1973.
Iron.
17 x 9 ½ x 12 in. (43.2 x 24.1 x 30.5 cm).

with the one constructed in the West. Its impulse being at the same time nationalistic and internationalist, it looked inward as well as outward. In art, its languages included both realism and abstraction, but formal issues were not its primary problems: the fundamental questions of Iranian modernism addressed the notion of identity. Ironically only now—when this "ism" is consigned to history and cultural difference has gained a new authority—are we ready to begin to listen.

NOTES

In a long list of people I wish to thank I will start with Lynn Gumpert for inviting me on board and especially for her openness to modern art of non-Western origin. Next, my heartfelt thanks go to Shiva Balaghi for her intellectual vigilance and her encouragement throughout the project. In my research I am indebted to a number of people without whose generosity and knowledge my task would have been simply impossible. Space limitations do not allow me to thank them individually but only to list them alphabetically. I would like to cheat, however, and mention first and foremost Marcos Grigorian, for his unconditional availability and the invaluable documents he shared with me; Leyly Matine-Daftary, herself an accomplished artist, whose work is absent from the Grey collection but who has not hesitated in answering all kinds of tedious questions; Lili Golestan, for making certain documents accessible and for help in the difficult task of obtaining one of the photographs; Farhad Daftary, for offering his knowledge of Iranian history; and Karim Emami, for sharing his archives, contacts, and experience. To them and all the others listed below I offer my deepest gratitude. They are Badri Ajudani, Siah Armajani, Ahmad Ashraf and the office of Iranian Studies, the late Ghodsi Chubak and her son Roozbeh Chubak, Farideh Daftari, Layla S. Diba, Kamran Diba, Goli Emami, Kamran Fani, Monir Shahroudy Farmanfarmaian, David Frankel, Farrokh Ghaffari, Zari Ghassemian, Ebrahim Golestan, Guitty Hakimi, Bahman Heydarian, Mahmud Javadipur, Bijan Kalantari, Karen Kurczynski, Abbas Mashhadizadeh, Massoud Nader, Manijeh Mir-Emadi Nasseri, Lucy Oakley, Behjat Sadr, Bijan Saffari, Parviz Tanavoli, Bragan Thomas, Manuchehr Yektai, Hossein Zenderoudi, Marie Zenderoudi, and Mrs. Ziapour.

1 Abby Weed Grey, *The Picture Is the Window, The Window Is the Picture,* (New York: New York University Press, 1983), p. 43. Mrs. Grey erroneously refers to the second Tehran Biennial as the first. For a biographical summary, see Lynn Gumpert, "Reflections on the Abby Grey Collection," in this volume.

2 For a thorough treatment of the subject, see *Royal Persian Paintings: The Qajar Epoch, 1785–1925,* ed. Layla S. Diba with Maryam Ekhtiar (London: I.B. Tauris Publishers in association with Brooklyn Museum of Art, 1998).

3 The artist himself was uncertain about his date of birth. The date on his tombstone reads end of Shavval, 1264 A.H., which corresponds to 1848. The essential monographs on Kamal al-Molk are Ahmad Soheili Khansari, *Kamal-e Honar: Ahval va Asar-e Mohammad Ghaffari Kamal al-Molk,* (Tehran: Soroush, 1989); and a collection/compendium of essays, recollections, and letters, with a bibliography: Ali Dehbashi, ed., *Kamal al-Molk,* (Tehran: Behdid, 1999).

4 For a history of Iranian photography with discussion of Kamal al-Molk's relation to it, see Chahryar Adle with Yahya Zoka, "Notes et documents sur la photographie iranienne et son histoire," *Studia Iranica* 21 (1983): 249–80.

5 Kamal al-Molk's sympathies with the Constitutionalist movement and personal dislike of Mozaffar al-Din Shah, who succeeded Nasir al-Din Shah, are well known, but the artist's views of Nasir al-Din Shah himself are not without a hint of critique, for example in his complaint that the *Hall of Mirrors* was, after all, an imposition. See his memoirs, in Dehbashi, p. 26.

6 Kamal al-Molk's portrait of Fantin-Latour (dated 1317 A.H./1899–1900) is probably a copy of the French artist's *Self-Portrait* of 1883, which entered the collection of the Uffizi Gallery, Florence, in 1895. Kamal al-Molk could have seen this work in Florence, where he lived before traveling to Paris and meeting Fantin-Latour. See Soheili Khansari, p. 22 and Pl. 269.

7 Michel Hoog, "Fantin-Latour and His Contemporaries," in *Fantin-Latour* (Paris and Ottawa: Réunion des Musées nationaux and National Gallery of Canada, in conjunction with the Fine Arts Museums of San Francisco, 1983), p. 32.

8　In his memoirs, Mozaffar al-Din Shah recounted a visit in 1900 to the Louvre, where he saw Kamal al-Molk in the act of copying. Soheili Khansari, p. 23, identifies the work as a copy after Titian's *Entombment*.

9　For an excellent discussion of teaching methods during the Qajar period, see Maryam Ekhtiar, "From Workshop and Bazaar to Academy," in *Royal Persian Paintings*, pp. 50–65.

10　Soheili Khansari, p. 179.

11　In the 1970s Aydin Aghdashloo, a painter and art historian, building on a tradition of copies after European masters, initiated a series of portraits characterized by altered appropriations. Among the works he has appropriated is a *Self-Portrait* by Kamal al-Molk, reproduced as a book jacket and more recently as a poster for the Tehran Museum of Contemporary Art (hereafter TMOCA).

12　Ru'in Pakbaz considers him as a pioneer of change. Aghdashloo argues that "one can neither blame Kamal al-Molk for undertaking Western Realism nor praise his dexterity in copying Rembrandt and Titian." He locates Kamal al-Molk at the conclusion of a development where Western elements and influence triumph. Both are cited in Dehbashi, pp. 185–92, 201, n. 3, and p. 162. Karim Emami, on the other hand, considers him the originator of modern art in Iran. See Karim Emami, "Post-Qajar (Painting)" in *Encyclopaedia Iranica,* ed. Ehsan Yarshater, vol.

2 (London and New York: Routledge and Kegan Paul, 1987), pp. 640–46.

13　On the *madreseh*, see Ekhtiar, pp. 61–62.

14　Ali Mirsepassi, *Intellectual Discourse and the Politics of Modernization: Negotiating Modernity in Iran* (Cambridge: Cambridge University Press, 2000), p. 61.

15　Ibid., p. 54

16　Nikki R. Keddie, *Roots of Revolution: An Interpretive History of Modern Iran.* (New Haven: Yale University Press, 1981), p. 186.

17　Dehbashi, p. 313.

18　The period dominated by Kamal al-Molk's students suffers from the absence of basic monographs and factual studies. At the moment it is impossible to determine whether gradual forces were eroding his influence. What remains evident is that Iranian reverence for the Old Master tradition never entirely died out. A remarkable contemporary manifestation can be seen in Y.Z. Kami, whose artistic genealogy goes back to the teachings of Mrs. Mahine Yusefzadeh, herself a student of Ali Mohammad Heydarian (1896–1990), one of Kamal al-Molk's best-known students.

19　On the Pahlavi era, see Homa Katouzian, *The Political Economy of Modern Iran: Despotism and Pseudo-Modernism, 1926–1979* (New York: New York University Press, 1981); Keddie; George Lenczowski, ed., *Iran under the Pahlavis* (Stanford, Calif.: Hoover Institution Press, 1978).

20　Reza Giorgiani, "Namayeshgah-e honarha-ye ziba-ye Iran," *Sokhan* per. 3, no. 1 (1946): 26.

21　Ibid., pp. 26, 28. Two months after Kamal al-Molk's death in 1940, the Honarkadeh was founded by the Minister of Culture within the framework of Tehran University (itself founded by Reza Shah in 1934), although its first location was on the premises of the Marvi Mosque. (Personal communication with New York-based artist Manouchehr Yektai, who was one of Honarkadeh's first students and who left Iran before the end of World War II.) See also Javad Mojabi, *Pioneers of Contemporary Persian Painting: First Generation* (Tehran: Iran Art Publishing, 1998), pp. 6–7.

22　For a biography, see "Godard" in *Encyclopaedia Iranica*, vol. 11 (forthcoming), pp. 29–31.

23　Yektai, who worked with Obbadi, relates that the latter had studied in Paris and remembers his Impressionist-style brushstrokes. For other students of Kamal al-Molk who taught at the Honarkadeh, see Mojabi, p. 7.

24　See the interview with her student, Mahmud Javadipur, in Mojabi, p. 190. Javadipur credits her with having acquainted the students with modern European painting, especially Impressionism. Yektai recalls that he first learned about Manet through a book she lent him (conversation with author). In the literature she is called Madame Ashoub or Madame

Aminfar. Mojabi says she was married to Dr. Amin Ashoubfar. Her first name was Martine (personal communication with Leyly Matine-Daftary).

25 See Frances Morris, "Introduction," in *Paris Post War: Art and Existentialism 1945–55* (London: Tate Gallery, 1993), p. 16.

26 For illustrations of Ziapour's early paintings, now lost, see Giorgiani's review in *Sokhan,* p. 26, for *Kaveh the Blacksmith,* and *Kavir* no. 1 (1948): 19, for *Public Bath.* The former is an Expressionist rendering of the blacksmiths' uprising and the latter a local scene filtered through a Cubist vocabulary. For Ziapour's later works see Mojabi, pp. 277–87.

27 Jalil Ziapour, "Naqqashi," *Khorus-e Jangi* no. 1 (1949): 10.

28 "Naqqashi va Maktab-e Kamel: Teori-ye Jadid-e Ziapour … " *Kavir,* Mehr 14, 1327 [1948], p. 13.

29 Information relayed to the author by Mahmud Javadipur, who checked his files for the exact dates of the gallery's existence (Mehr 2, 1328–Tir 25, 1329). Badri Ajoudani managed the gallery.

30 For an account of who went where, see Mojabi. On Houshang Pezeshknia, who studied in Istanbul but does not figure in Mojabi's book, see R[u'in] Pakbaz and Y[aghoub] Emdadian, *Pioneers of Iranian Modern Painting: Houshang Pezeshknia, Sohrab Sepehri, Hossein Kazemi* (Tehran: TMOCA, 2001). The

trend of Iranian artists going to Europe to study continued into the 1950s, and their trips were considered important enough to be reported as news in *Sokhan.* For example, for the returns of Mansoureh Hosseini, Abolghassem Saidi, Behjat Sadr, and Bahman Mohassess in 1959, see *Sokhan* per. 10, nos. 5, 6 (1959): 554, 663.

31 Mojabi, p. 191. Note that while Ziapour is not represented in the Grey collection, Javadipur is, with two works on paper.

32 The gallery operated between 1954 and 1959, except for a hiatus of nine months in 1955–56, when Grigorian went back to Italy (personal communication, January 2000). For reviews of exhibitions held there in 1956–57, see *Sokhan* 8, nos. 2, 3, 7. Aside from foreign cultural institutes, some of the other spaces where contemporary art was exhibited in Tehran in the 1950s were the Mehregan Club, the Talar-e Reza Abbasi, and, from 1958 on, Jazeh Tabatabai's Honar-e Jadid gallery. Further study of the exhibition spaces is very much needed.

33 The Tehran Biennial's declared purpose was to encourage modernist artists and to select works for the Venice Biennale (document given to the author by Marcos Grigorian). Jury members were drawn from the international art world. Five biennials were held, the last in 1966. For a review of the 1958 biennial, see Ehsan Yarshater, "Namayeshgah-e Bienal-e

Naqqashi va Peykarsazi dar Kakh-e Abyaz," *Sokhan* per. 9, no. 1 (1958): 82–84.

34 For further discussion of coffee-house paintings, see Peter Chelkowski, "The Art of Revolution and War: The Role of the Graphic Arts in Iran," in this volume. In an article published in *Ajang* (having seen only a partial photocopy, I am not able to confirm the date, but based on internal evidence, it may be dated between 1958, when Grigorian directed the Tehran Biennial, and 1960, when he left for the United States), Grigorian explains how he discovered such paintings in a butcher's shop and asserts that he finds them more valuable than "cheap copies of European paintings."

35 Farhang Farahi, *Galerie Esthétique* no. 1 (n.d.): 5, 15. Grigorian states that he published three issues of this magazine.

36 For example, Cyrus Zoka's attack on abstraction in his review of the 1962 Tehran Biennial in *Sokhan* per. 13, no. 1 (1962): 116–22.

37 Gavin R.G. Hambly, "The Pahlavi Autocracy: 1921–1941," *The Cambridge History of Iran,* vol. 7: *From Nadir Shah to the Islamic Republic,* ed. P. Avery et al. (Cambridge: Cambridge University Press, 1991), p. 236.

38 Jalal Al-e Ahmad, *Gharbzadegi. Occidentosis: A Plague from the West,* Persian Series (Berkeley: Contemporary Islamic Thought, 1983).

39 For an illuminating study of Al-e Ahmad and Ali Shar'ati, who

further developed Al-e Ahmad's ideas and became an important voice of dissent in the 1970s, see Mirsepassi, pp. 96–128. For the quotation, see p. 127.

40 Cyrus Zoka, review of the Tehran Biennial, *Sokhan* per. 13, no. 1 (1962): 118.

41 Ibid., p. 120.

42 From the Venice Biennale Barr also acquired Faramarz Pilaram's *Laminations,* 1962, for the Museum of Modern Art.

43 Before enrolling at the Beaux-Arts in Paris she was a student at the Honarkadeh, where she used her knowledge of French to interpret between Madame Aminfar and the students (Yektai, personal communication). For a brief biographical sketch, see Mojabi, p. 21.

44 For an illustration, see the catalogue of the 1960 Tehran Biennial, p. 87. As far as one can judge from the poor black-and-white reproduction, both in spirit and execution the work resembles paintings by Zenderoudi's teacher Shokouh Riazi, who had returned from Paris in 1955 soon after her graduation.

45 Grigorian owns a photograph of an opening reception where his student, a young female painter whose name he could not remember, stands before a coffee-house-type painting she had executed.

46 Grigorian offered printing classes at the Honarestan-e Honarha-ye Ziba between 1958 and 1960. In fall 1960 Zenderoudi moved on to the School of Decorative Arts.

47 One was exhibited at the Talar-e Reza Abbasi. A photograph of the Queen visiting helps date the exhibition to 1960, when she was several months pregnant. This work was acquired by Tanavoli, who sold it to Sadeg Chubak. The other work was also purchased in 1960; today it is in a private collection in Europe. Zenderoudi recalls having made only two such linocuts. One is reproduced in Laleh Bakhtiar's essay in *Religious Inspiration in Iranian Art* (Tehran: Negarestan Museum, 1978), p. 22, where it is dated c. 1960. The late Mrs. Chubak recalled having acquired the *pardeh* soon after she and her husband returned to Iran in 1960 (personal communication, spring 2001).

48 For the types of objects Zenderoudi would have known, see David Galloway, ed., *Parviz Tanavoli: Sculptor, Writer and Collector* (Tehran: Iranian Art Publishing, 2000), pp. 86–93.

49 In 1961 he exhibited *Fantasy,* which according to a reviewer was 15 meters long. See "Preview," *Tehran Journal,* May 17, 1961. In the newspaper illustration one can make out the silhouette of a robe and the inscription "Shavval 13, 1380 [March 31, 1961]."

50 Personal communication, New York, April 2001.

51 Karim Emami, "A New Iranian School," *Kayhan International,* June 5, 1963, p. 6.

52 Policies of modernization constitute an extensive subject that deserves separate treatment.

See Djamshid Behnam. *Cultural Policy in Iran* (Paris: Unesco, 1973). For American accounts written after the Revolution, see "Tehran Report," *Art in America* 69, no. 8 (October 1981), a roundup of articles including Sarah McFadden, "The Museum and the Revolution," pp. 9–16; Robert Hobbs, "Museum Under Siege," pp. 17–25.

53 For an illustration, see the catalogue of the first Tehran Biennial, 1958, p. 26.

54 Karim Emami, "A New Iranian School," *Kayhan International,* June 5, 1963, p. 6. Emami remembers, however, that his first use of the term *saqqakhaneh* dates back to a review he wrote of the 1962 Tehran Biennial. In addition to his insightful art criticism, Emami is one of the few to publish overviews of modern Iranian art. Along with Ru'in Pakbaz, Akbar Tajvidi, and Ehsan Yarshater, he provided the groundwork for my initial research.

55 On *Saqqakhaneh* as both an art movement and a ceremonial site, see Karim Emami, "Saqqakhaneh School Revisited," and Peter Lamborn Wilson, "The Saqqa-khaneh," in *Saqqakhaneh* (Tehran: TMOCA, 1977). A younger generation of contemporary artists such as Sadegh Tirafkan and Khosrow Hassanzadeh, whose collaborative *Ashoura* installation was exhibited at TMOCA in Summer 2001, have found inspiration in Saqqakhaneh and its Shiite iconography.

56 Except for Massoud Arabshahi,

they are all represented in the Grey Art Gallery's collection.

57 For illustrations of his sculptures, which are not represented in the Grey collection, see "Jazeh Tabatabai," *Tavoos* nos. 5–6 (Autumn 2000–Winter 2001): 18–26. In the winter of 1958–59 Tabatabai opened his "honar-e jadid" gallery, where he exhibited children's paintings, among other things. See *Sokhan,* per. 10, no. 4 (1959): 435.

58 See David Galloway, ed., *Parviz Tanavoli: Sculptor, Writer and Collector.* (Tehran: Iranian Art Publishing, 2000).

59 Tanavoli claims he gave Zenderoudi three exhibitions. At least two are documented: one was reviewed in the *Tehran Journal,* May 17, 1961, and a poster records another exhibition that was held October 19–24, 1961.

60 Emilio Greco had left Carrara by the time Tanavoli arrived, but his influence lingered on. On Greco, see *Sculptures and Drawings,* with text by J. P. Hodin (New York: The Contemporaries, 1961).

61 Abby Grey was traveling with MAP (Minnesota Art Portfolio), an exhibition of contemporary drawings and prints by American artists, and Tanavoli, along with Marcos Grigorian, Bijan Saffari, Sohrab Sepehri, and Manouchehr Sheibani, had formed an association of independent artists. As an act of defiance protesting the lack of official attention to contemporary artists, they were exhibiting together at the Saderat Bank, where Grey and Tanavoli met. For further details, see Grey, pp. 65 ff.; Tanavoli, pp. 71 ff.; and Lynn Gumpert, "Reflections on the Abby Grey Collection," in this volume.

62 Armajani explains that he found his earliest influence in nineteenth-century calligraphy of Persian poetry (personal communication, February 21, 2001).

63 Entitled *Prayer,* the picture is in the Walker Art Center in Minneapolis. For a reproduction, see Jean-Christophe Amman, *Siah Armajani* (Basel: Kunsthalle; Amsterdam, Stedelijk Museum, 1987), n.p.

64 A study on the role of Michel Tapié de Ceyleran (1909–1987) and the Iranian modernists he helped promote would be timely. Tapié was the art critic and champion of "art autre" who introduced Zenderoudi to the Lettristes and who for many years ran the Cyrus Gallery at the Maison de l'Iran in Paris, where he showed works by several Iranian artists, including Faramarz Pilaram in 1972 and Behjat Sadr in 1975.

65 Dave Hickey, *The Invisible Dragon: Four Essays on Beauty* (Los Angeles: Art Issues Press, 1993).

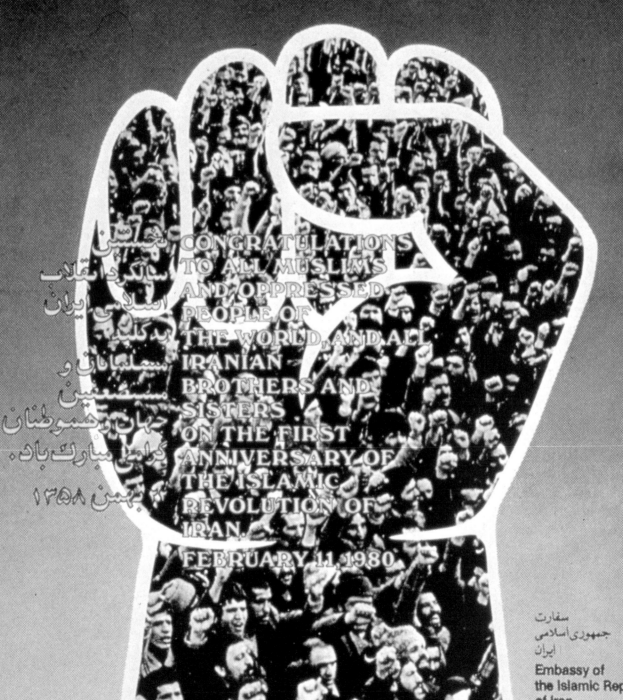

جاء الحق و زهق الباطل ان الباطل كان زهوقا

حق آمد و باطل نابود شد،
همانا که باطل نابود شدنی است.

Truth has come and falsehood has vanished, verily falsehood is ever bound to vanish.
Quran 17:81

قرآن، سوره بنی اسرائیل، آیه ۸۱

CONGRATULATIONS TO ALL MUSLIMS AND OPPRESSED PEOPLE OF THE WORLD, AND ALL IRANIAN BROTHERS AND SISTERS ON THE FIRST ANNIVERSARY OF THE ISLAMIC REVOLUTION OF IRAN. FEBRUARY 11, 1980

سفارت
جمهوری اسلامی
ایران

Embassy of
the Islamic Repu
of Iran
3005
Massachusetts Ave.,
Washington, D.C. 20

MULTIPLE ICONOGRAPHIES: POLITICAL POSTERS IN THE IRANIAN REVOLUTION

by Haggai Ram

S OCIAL UPHEAVALS and revolutionary struggles often give rise to innovative forms of political artistic expression. In order to build "insurgent consciousness," this art talks back to power, subverts its authority, and proposes alternative, oppositional ways of thinking and behavior.[1] In times of turmoil, when hegemony is at best constricted, this art engages in the construction of new symbols, countermyths, and, ultimately, new meanings.

The political posters that were produced and disseminated during the Islamic Revolution in Iran were no exception. Created by artists committed to the Revolution, these posters clearly set out to redefine social values and norms, and to produce what François Fubert has called "a new mystique," at once liberating and envisioning a blissful future.[2] As the Shah's authority diminished, engaged artists produced posters whose iconography opposed and inverted ideas and images that supported the status quo. Not just a secondary reflection of the revolutionary movement, these posters played a vital role in the struggle for change and in the articulation of collective ideology. In this sense, the Revolution and its art were mutually constitutive.

The revolution marked a defining moment in Iran's modern history. Occurring in a period relatively free of the heavy hand of both the pre- and the post-1979 governments, the Revolution and its art produced multiple

layers of meanings and iconographies. These multiple iconographies bridged the literary with the visual, the past with the present, the sacred with the profane, the modern with the traditional, and the national with the international. As will be seen, these multiple meanings defy all reductive explanations of the Revolution as purely "Islamic" and challenge the stereotypical view of Islam as iconoclastic.

The role of political posters in the Iranian revolution has been addressed in a number of scholarly studies.[3] Generally, the studies focus on how these posters combine two graphic styles, the one local and the other international, the one "traditional" and the other "modern." In this way, they view the Iranian revolutionary poster as emblematic of the hybrid, postmodern character of emergent cultural formations in Iran. As Michael J. Fischer and Mehdi Abedi have suggested,

> The revolutionary posters of the Iranian revolution … vividly
> articulate the cultural interreferences of modern Iran, bringing
> together on the one hand traditional graphic traditions of the
> Persian miniature, of murals used as props by epic storytellers,
> and of calligraphic and arabesque design, and on the other hand
> an international third-world revolutionary modernist graphic
> lineage that dates back via the Cuban revolution to the Russian
> revolution. Often different posters fit into one or the other
> tradition. But not infrequently, these two traditions come
> together in brilliantly powerful condensations, or in equally
> powerful disseminations (in which two sets of meanings do not
> fuse but remain in creative tension generating different chains of
> associations).[4]

In what follows, I will tell a somewhat different story of the Iranian revolutionary poster. Focusing on its multiple iconographies, I will attempt to highlight the very diversity and richness of the revolutionary culture, its ruptures and continuities, and its unresolved contradictions. Although the Revolution culminated in an Islamic state—that is, the self-proclaimed authentic embodiment of pure Islam—its impetus and motivations, and, accordingly, its iconography, images and messages, were multifarious.

Three posters provide a point of departure for our examination. All three make direct appeals to action by defying power, subverting authority, and inverting icons as a means to authorize oppositional ways of thinking

and behavior. For example, in one poster the Shah's oil regime becomes a weapon of its own destruction, as an oil derrick stands in for the hilt of a dagger plunging through the United States-supported Pahlavi crown. [Fig. 24] Another poster suggests that in order to create a better future, it is necessary for people to be active and to take risks in the present. [Fig. 25] Here, the revolution is visualized as a red arrow that will arrive at the gates of a blissful future, exemplified in the poster by a red sun. However, what must precede this destiny is an arduous struggle against three obstinate forces, represented by three columns. The revolutionary arrow has already broken through the first column on which the Pahlavi crown stands perilously. The second column is marked "internal reaction" and upholds a silhouette of the Shah's profile. Uncle Sam's hat sits atop the third column that is labeled "imperialism." Another poster juxtaposes a photograph of a crowd of people with a huge outline of a hand that is about to propel a spherical American flag out of the frame of the image. [Fig. 26] A bright destiny is implied for these demonstrating masses, rendering their painful present as relative and temporary, provided, as the text printed in red states, that they "continue the Revolution … until the [total] termination of plundering."

It is interesting to note that the Islamic Republican Party issued the first and third posters described above. Yet neither of them, nor the second, makes any explicit reference to Islamic imagery. Nor do they make specifically religious claims. Employing typical third-world anticolonial imagery, they link the Iranian Revolution with similar struggles elsewhere in the world.[5]

However, the revolutionary poster, like the revolutionary culture it helped constitute, is, as mentioned, multifaceted and diverse, with multiple iconographies. Neither the poster nor the revolution itself can be explained away merely in terms of the "secular," nor can they be dismissed as simply "religious." In many instances Islamic imagery was harnessed to the task of nurturing and sustaining an "insurgent consciousness." As a primary marker of cultural authenticity, Islam provided a host of visual symbols to stimulate a struggle for political emancipation and national liberation.

One poster vividly demonstrates how the revolutionary artists often conflated themes of third-world anti-colonial struggles with religious symbolism. [Fig. 43] As the logo at the lower right clearly indicates, this poster was issued by the movement of The People's Mojahedin (*Mojahedin-e Khalq*), which was "the first Iranian organization to develop systematically a modern revolutionary interpretation of Islam."[6] The poster depicts a disembodied,

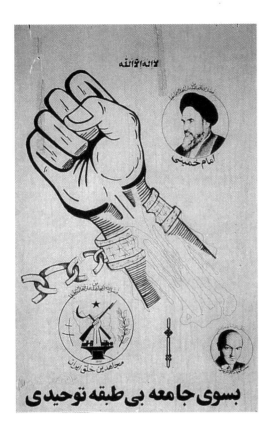

Fig. 43.
Poster with a chained hand.
c. 1970–79.
35 x 23 in. (88.9 x 58.4 cm).

clenched fist freeing itself from the chains of bondage. The fist represents the empowering agency of Allah, whose name is inscribed in the veins of the forearm. Encircled miniature portraits of Imam Khomeini and Dr. Ali Shari'ati hover in the upper and lower left corners. Both these men, albeit for totally different reasons and motivations, helped transform Shiite Islam into a *worldly* and a *third-worldly* program for anti-colonial struggle and national liberation.[7] Overlapping religious and anti-colonial, Marxist iconographies are revealed in the slogan at the bottom of the poster, which reads: "towards a classless *tawhidi* society." An Islamic term for monotheism, *tawhid* is also a revolutionary neologism that came to mean "unitary" and, by extension, "classless."[8] The poster thus makes visual the connection between a monotheistic Islamic society and a classless Marxist society.

Another striking example of how Islamic iconography subverts power is found in a poster commemorating Zeinab. [Fig. 27] The daughter of Ali, the first Shiite Imam, and sister of Hossein, the third Imam, Zeinab is

best known for her leadership role following the historic battle of Karbala in 680 A.D. The battle of Karbala, which has a deep ontological meaning for Shiites, was waged between Hossein, representing the Household of the Prophet (*ahl-e beit*), and the Umayyad Caliph Yazid. After the massacre of Hossein and seventy-two of his companions, Zeinab assumed the leadership of the women and children who were taken prisoner to the court of the Caliph Yazid in Damascus. Zeinab "kept the survivors of Karbala together and maintained the message of Husayn until the [ailing] fourth Imam had recovered and could assume political leadership."[9] The poster thus urges that all Iranian women emulate Zeinab's heroic and steadfast leadership in times of crisis and despair.

Interestingly, in the poster the figure of Zeinab is depicted in the negative—as a white silhouette—with her thrusting, clenched fist shattering a simplified bright-red-and-green form representing the palace and crown of Yazid. Contained within Zeinab's silhouette is a crowd of contemporary veiled Iranian women collectively assuming her identity. These women—their white faces emerging from a field of black chadors—also raise their fists and, more significantly, become visible *only* through the simultaneous absence and presence of white-shrouded Zeinab. The poster graphically conveys what these contemporary women are expected to do: like Zeinab, they must destroy the palace and crown of "Yazid of their own age" (*Yazid-e zaman*), the Pahlavi Shah. As Chelkowski and Dabashi point out in relation to this same poster, "the smashed crown ... is as much Yazid's as the Shah's."[10]

Zeinab's iconography not only induces women actively to oppose power, it also tells them exactly *how* they can do so. An inscription at the bottom of the poster reads: "Zeinab, Oh spokesperson of Ali"; to the left is the convoy of camels and white-shrouded women, each carrying a baby child, advancing toward the palace of Yazid. While a prisoner in Yazid's court, Zeinab spoke out defiantly against the caliph's tyranny, keeping alive the message of Imam Hossein. Thus, the caravan that took Zeinab and the other Karbala prisoners to Damascus came to be known in Shiite popular imagination as *karvan-e tabligh-e Karbala*—"the caravan of the propagation of [the tragedy] of Karbala."[11] To oppose power, therefore, implied revealing the tyrannical nature of the Shah's regime, that is, to *speak out* against the Pahlavi monarchy. In this way, each and every devoted Iranian woman becomes a Zeinab and thus symbolically joins the convoy of prisoners to Damascus.

Yet Zeinab's story can only be fully grasped within the broader context of the Karbala paradigm: that is, the story of the martyrdom suffered by

Imam Hossein and seventy-two companions on the plains of Karbala. The focus of this story, as Michael Fischer explained, "is the emotionally potent theme of corrupt and oppressive tyranny repeatedly overcoming (in this world) the steadfast dedication to pure truth; hence its ever-present, latent, political potential to frame or clothe contemporary discontents."[12] Accordingly, since 1963, Khomeini and other like-minded oppositionists had often articulated their struggle against the Pahlavi monarchy as a reenactment of the battle of Karbala; they assumed the righteous role of Hossein, and the Shah was portrayed as the usurper Yazid. This metaphorical paradigm reached a climax during the Revolution, when Iranians were called upon to emulate their martyred Imam—to follow in his footsteps and be willing to shed blood for the Revolution.[13]

Indeed, images of martyrdom feature prominently in revolutionary posters. Their representations embody a two-fold objective: to commemorate the fallen and to sanctify the loss of life by those engaged in the revolutionary struggle. Jay Winter, in his study of the practices of commemoration and mourning in Europe during and after the Great War, suggested, "however 'modern' the Great War was, its immediate repercussion was to deepen and not transform older languages of loss and consolation."[14] This, Winter notes, provided a way of remembering that enabled the bereaved to live with their losses, and perhaps to leave them behind. In a sense, revolutionary posters likewise can be seen as modern sites of commemoration, which invoke "traditional" motifs and images about sacrifice and death as a means of helping survivors cope with their loss and trauma. For example, one poster reproduces a black-and-white headshot of a young man, apparently killed in the anti-Shah struggle. The photograph is embellished with a Koranic verse saying that God prefers the *mojahed*—in this case, a holy martyr—to "those who desist." [Fig. 44] In death, Mohammed Bazargani, a member of

Fig. 44. Poster of a martyred member of the Mojahedin. c. 1980–88. 14 x 10 in. (35.6 x 25.4 cm).

the Mojahedin-e Khalq who was slain in the revolution, assumes the stature of an "Islamic martyr" (*mojahed shahid*). In a search for comfort, then, older motifs were combined with recent ones, taking on new meanings.

Another poster provides similar comfort and consolation. [Fig. 29] On the right, a kneeling man dressed in black is shot, and then falls, drenched in blood, clasping a red tulip. His fall is shown in a series of four freeze frames. Covered with blood, he is in the end prostrate, blending in with the blood-red ground in a kind of a mystical union. In martyrdom he achieves unity, the ultimate goal of the mystical quest. Significantly, the tulip is a familiar metaphor in Persian Sufi allegorical poetry, associated with the blood of lovers shed in the quest for the Beloved. This helps explain why "the tulip has become the icon of martyrdom for the Islamic Republic, and it is one of the most omnipresent symbols in the republic's visual arts."[15] In sum, spiritualist representations of martyrdom helped Iranians to come to terms with their losses in the Revolution, just as "spiritualist communion" of a similar kind reached a high point in the period of the 1914–1918 war in Europe.[16]

A caption along the bottom left of the poster indicates that it was produced in conjunction with an exhibition on the Islamic Revolution that was held when the Hosseiniyyeh-e Ershad seminary reopened. Interestingly, the event was organized in collaboration with the students of the Fine Arts College at the University of Tehran. This exhibition celebrating the seminary reopening thus exemplifies the multifarious culture of the Revolution—one that bridges the particular with the universal, the "secular" with the "religious," the national with the Islamic. Founded in 1964, Hosseiniyyeh-e Ershad seminary marked a crucial development in the process of forming and popularizing modern Shiite views that were later incorporated into the "Islamic" teachings of the revolution.[17] Lecturers at this institution, such as Ali Shari'ati, included many of those who helped articulate a modern Islamic ideology. Hosseiniyyeh-e Ershad was eventually closed down by the Shah's regime. On the other hand, the University of Tehran, which was inaugurated in 1934, has been identified, even after 1979, as the bastion of the Pahlavi monarchy's type of Westernized modernization.[18] This coming together of two seemingly conflicting institutions of learning demonstrates that the culture of the revolution was the product not of the exceptionality of "Islam," but rather of the dialectical accommodation and selective appropriation of indigenous and exogenous, "Eastern" and "Western," national and international influences. Thus, all reductive explanations of the Revolution as strictly "Islamic" are, at best, insufficient.

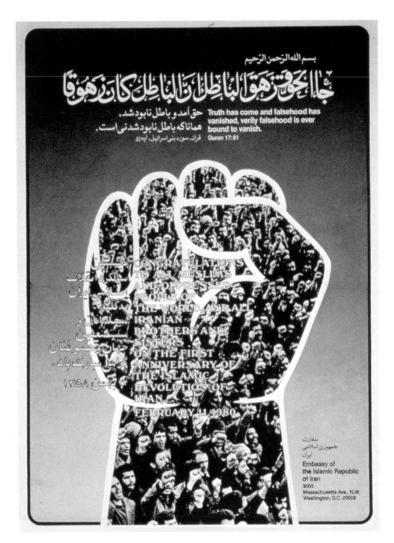

Fig. 45. Poster with a clenched fist. 1980.
31 x 24 in. (78.7 x 61.2 cm).

A poster commemorating the first anniversary of the Revolution encapsulates in a remarkable manner the complex hybrid culture of the revolution. [Fig. 45] In it the national and the international, Iranian particularism and Islamic universalism, are all enmeshed to the point where they constitute a single discursive field. Dominating the poster is an enormous, simplified clenched fist containing within itself a photograph of a mass of demonstrators, also with raised fists. The text in red, superimposed in both

Persian and English over the fist, congratulates "all Muslims and oppressed people [sic] of the world, and all Iranian brothers and sisters on the first anniversary of the Islamic Revolution of Iran." The Koranic verse running along the top alludes to the victory of "truth" (haqq, i.e. the Revolution) over "falsehood" (batel, i.e. the enemies of the Revolution, internal as well as external).

The poster, then, makes its appeal far beyond Iranian borders, to embrace "all Muslims and oppressed people of the world." At the same time, however, its primary frame of reference remains wedded to the conception of the Iranian nation as embodied in the masses who are shown to have carried out the "Islamic Revolution of Iran." The poster confronts "global oppression" and, more specifically, oppression against Muslims anywhere. Yet at the same time it bears a distinctly Iranian message: the community it denotes, and inculcates pride in, is clearly limited to the boundaries of modern-day Iran. Indeed, in this poster Iran assumes the role of a "redeemer nation."[19] Compared with other nations, Iran alone possesses the special leadership qualities required to bring about the liberation of the world's oppressed. Significantly, this conflation of nationalist, Islamicist, and internationalist concerns can also be seen in many posters commemorating May Day in the early years of the Islamic Republic of Iran.[20]

Yet revolutions are also—perhaps principally—struggles over memory. A revolution requires "more than a cult of saints," writes Matt K. Matsuda about the meaning of the toppling of the Vendôme Column in Paris in 1871. "It required war on the memories of the old order … [H]umanity would be possible only when such memories were destroyed, the old forms and vestiges crumbling as their props were pulled down."[21] In the Iranian Revolution, too, the commitment to break with the past provided a foundation upon which to build a new society. Like the Paris Commune in 1871, the Iranian revolutionaries of the 1970s "sought to exorcise the past in the name of the future."[22] Accordingly, they set out to eradicate the hegemonic historical narrative of the Pahlavi monarchy by creating a counter-historical narrative that was ideally structured to fit the new teleology of the revolution. Thus, while pivotal "moments" in the master commemorating narrative of the ancient regime—such as the launching of the White Revolution in 1963, the Shah's self-coronation in 1967, and the 2,500th anniversary of the Persian monarchy in 1971—were abolished, new ones were created in their place. Not surprisingly, revolutionary posters were harnessed to this task of inculcating a restructured historical awareness.

One clear example is a poster commemorating the uprising of Fifteenth of Khordad (June 5) 1963, when Khomeini was arrested for leading protests against the Shah's White Revolution. In the course of this uprising the authorities quelled resistance among the religious students in the central Feiziyya seminary in Qom, and a number of students lost their lives.[23] [Fig. 30] Positioned on the right within the outline of the country silhouetted against a black field, the figure of Khomeini is seen addressing a crowd in 1963, inciting the masses to protest nationwide. On the left, disembodied arms holding rifles aloft provide a visual representation of this kind of resistance. Yet this poster was not intended merely to commemorate an isolated event. Rather, it attempted to create, retrospectively, a meta-narrative of Iranian history that was similar to that of the Pahlavis' only in form, "imbedded in secular time, with all its implications of continuity."[24] In terms of content, however, this revolutionary narrative recounted a very different story. The historiography produced by the Shah viewed the years of the White Revolution as times of majestic power and benevolent modernization. That of the revolutionaries did not: "The Fifteenth of Khordad [is] the starting point of the revolt (*qiyam*)," states the inscription at the bottom of the poster, and with it there emerges an entirely different narrative of the White Revolution. It is a narrative that draws a direct line between the 1963 uprising and the Islamic Revolution, and so it tells a story of utter disenchantment with the Shah's program of modernization. In the final analysis, post-1963 Iranian history becomes a story of uninterrupted resistance leading to and through the Revolution of 1979. A neat, linear, and progressive historical narrative of revolution, with a promising beginning and fulfilling ending, displaced that of the Shah. "Not mere rage nor effacement of symbols was taking place, but a sacred transition, of both political and spiritual legitimacy."[25]

Yet the counter-narrative of the revolution reached its (teleo)logical conclusion only with the official date commemorating the triumph of the Islamic Revolution. The date chosen for this momentous occasion was 22 Bahman (February 11) 1979, the day when the last stronghold of resistance of the Shah's regime was overcome. Another poster, for example, proclaims 22 Bahman "the day of the victory of the Islamic Revolution of Iran." [Fig. 23] In it a bullet is shown in five stages, at the top mostly white and the remaining four progressively covered with blood. The image implies that victory was achieved with the blood of the people; that the Revolution, to echo Ayatollah Khomeini's famous words, represents the quintessential "triumph of blood over the sword."[26]

The posters analysed here provide visual testimony to the wealth and heterogeneity of the Revolution's cultural, and social, and political concerns. Drawing on traditional Shiite sources, they also equally incorporate ideas from a variety of other sources, including Marxism, to fashion a militant, subversive, and sometimes contradictory political message. This ideology, as we have seen, focused not on issues of scripture and theology, but on immediate, local, and global grievances and needs. Within this context, 22 Bahman marked a turning point in the history of political posters in Iran, because it triggered a process that resulted in the formation of a centralized state under the leadership and control of the Islamic current. Henceforth, and especially after the brutal monopolization of power by Khomeini's people in June 1981, all political socialization came under the direct and exclusive control of the state. Political posters bearing the stamp of the Islamic Republic have another fascinating story to tell. Suffice it to note that, though created under the purview of an "Islamic regime," they are as complex and multiple in their imagery and iconography as the earlier posters discussed in this essay. A series of Warhol-esque posters of leading Iranian clerics, including Khomeini, produced by the Islamic government of Iran in the 1980s, is one vivid example of this. [Fig. 31] They confirm the view that political symbols expressing the ideals and principles of the new order draw on a variety of sources, indigenous and exogenous, and cannot be subsumed under a rigid and inflexible category of "Islamic fundamentalism." Perhaps there is more cultural pluralism in the Islamic Republic of Iran than has been acknowledged.

NOTES

I am grateful to Ed Jajko of the Hoover Institution at Stanford University for his generous assistance while I was working on the poster collection. Much of the research for this article was undertaken while I was a visiting scholar at the Hagop Kevorkian Center at New York University. I would like to thank Farhad Kazemi, Peter Chelkowski, Timothy Mitchell, Zachary Lockman, and Lynn Gumpert for their hospitality and support for this project. Last but not least, I am grateful to Shiva Balaghi for her cogent and challenging comments and suggestions, and for her enduring support, which helped me through this project.

1 George Lipsitz, "Not Just Another Social Movement: Poster Art and the Movimiento Chicano," in *Just Another Poster? Chicano Graphics in California*, ed. Chon A. Noriega (Santa Barbara: University Art Museum, University of California, Santa Barbara, 2001), p. 76.

2 Furet uses this phrase with reference to the French Revolution of 1789. François Furet, *Interpreting the French Revolution* (Cambridge: Cambridge University Press, 1981), p. 114.

3 See William Hanaway, "The Symbolism of Persian Revolutionary Posters," in *Iran since the Revolution*, ed. Barry

Rosen (Boulder: Social Science Monographs, 1985); Michael M. J. Fischer and Mehdi Abedi, *Debating Muslims: Cultural Dialogues in Postmodernity and Tradition* (Madison: University of Wisconsin Press, 1990), pp. 333–82; Peter Chelkowski and Hamid Dabashi, *Staging a Revolution: the Art of Persuasion in the Islamic Republic of Iran* (London: Booth-Clibborn, 1999). See also Ervand Abrahamian, *Khomeinism: Essays on the Islamic Republic* (Berkeley: University of California Press, 1993).

4 Fischer and Abedi, p. 339.

5 Perhaps this is why Hanaway found revolutionary posters to be reminiscent of the artistic styles of the Russian and Cuban revolutions.

6 Ervand Abrahamian, *Radical Islam: The Iranian Mojahedin* (London: I. B. Tauris, 1989), p. 1.

7 The secondary literature on Shari'ati and Khomeini is vast. English readers can consult Shari'ati's and Khomeini's own writings translated into English. See for example 'Ali Shari'ati, *Hajj*, trans. A. Behzadnia and N. Denny (Houston, 1980); Ali Shari'ati, *Marxism and Other Western Fallacies: An Islamic Critique*, trans. R. Campbell (Berkeley: Mizan Press, 1980); R. M. Khomeini, *Islam and Revolution: Writings and Declarations of Imam Khomeini*, trans. and annotated by Hamid

Algar (Berkeley: Mizan Press, 1980).

8 Mehrzad Boroujerdi, *Iranian Intellectuals and the West: The Tormented Triumph of Nativism* (Syracuse: Syracuse University Press 1996), p. 117.

9 Michael M. J. Fischer, *Iran From Religious Dispute to Revolution* (Cambridge: Harvard University Press, 1980), p. 214.

10 Chelkowski and Dabashi, p. 102.

11 For post-revolutionary representations of Zeinab see Haggai Ram, *Myth and Mobilization in Revolutionary Iran: The Use of the Friday Congregational Sermon* (Washington, D.C.: American University Press, 1994), pp. 84–85.

12 Fischer, *Iran From Religious Dispute to Revolution*, p. 13.

13 On the Karbala paradigm and the Revolution see ibid., especially pp. 181–244; Mary Hegland, "Two Images of Husain: Accommodation and Revolution in an Iranian Village," in *Religion and Politics in Iran: Shi'ism from Quietism to Revolution*, ed. Nikki R. Keddie (New Haven: Yale University Press, 1983); and Haggay [Haggai] Ram, "Mythology of Rage: Representations of the Self and the Other in Revolutionary Iran," *History and Memory* 8 (Spring/Summer 1996): 67–87.

14 J. M. Winter, *Sites of Memory, Sites of Mourning: The Great War*

in *European Cultural History* (Cambridge: Cambridge University Press, 1998), p. 76.

15 Fischer and Abedi, p. 345.

16 Winter, pp. 54–77.

17 Ali Mirsepassi, *Intellectual Discourse and the Politics of Modernization: Negotiating Modernity in Iran* (Cambridge: Cambridge University Press, 2000), pp. 91–93.

18 David Menashri, *Education and the Making of Modern Iran* (Ithaca: Cornell University Press, 1992), pp. 143–54.

19 R. K. Ramazani, *Revolutionary Iran: Challenge and Response in the Middle East* (Baltimore: Johns Hopkins University Press, 1988), p. 20.

20 Abrahamian, pp. 60–87.

21 Matt K. Matsuda, *The Memory of the Modern* (New York: Oxford University Press, 1996), p. 36.

22 Ibid., p. 43.

23 According to Fischer, *Iran From Religious Dispute to Revolution*, p. 124, "for three days disturbances continued in Tehran, Qom, Mashhad, Isfahan, and Shiraz, and precautionary measures were taken elsewhere. Thousands died."

24 Benedict Anderson, *Imagined Communities: Reflections on the Origin and Spread of Nationalism* (London: Verso, 1991), p. 205.

25 Matsuda, p. 27.

26 Khomeini, *Islam and Revolution*, p. 246.

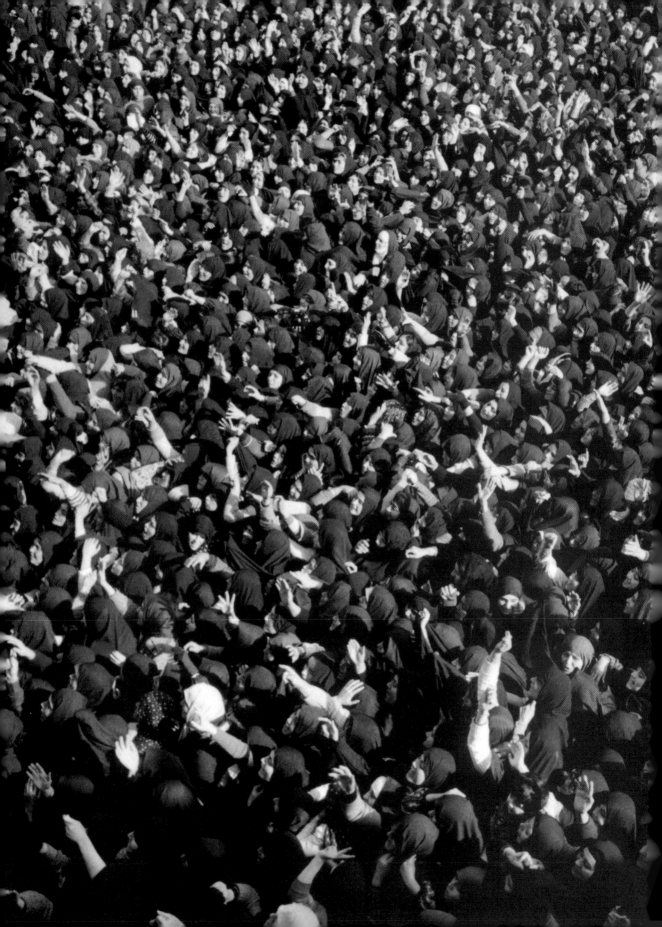

WRITING WITH LIGHT: ABBAS'S PHOTOGRAPHS OF THE IRANIAN REVOLUTION OF 1979

by Shiva Balaghi

I am a photographer, don't forget. I write with light.

A S EARLY AS 1977, Abbas's photographs were beginning to tell his story of the Iranian Revolution of 1979. Born in Iran in 1944, Abbas moved to Algeria with his family when he was eight years old. There, he watched the Algerian War of Independence unfold, and it was in that context that Abbas first became a journalist and photographer.[1] In the late 1970s, he returned to Iran with the idea of examining the social and economic changes brought on by the country's rapidly expanding oil industry. With this purpose in mind, Abbas began working on a photo-essay based on twelve Iranians who stood in the interstices of society—individuals whose lives could reveal the social implications of Iran's modernization programs. This project was disrupted by the outbreak of the Revolution in 1978, but the photographs that Abbas had already taken offer episodic glimpses of life in Iran in the pre-revolutionary period. The Shah and his generals strike dignified poses in their military regalia; peroxide blonde women exchange greetings in a beauty salon; men linger casually over drinks at an outdoor café; an aging worker eats a solitary lunch of bread and cheese on the workshop floor; a young shepherd boy plays in the skeleton of a wrecked car as his sheep graze in the arid desert. [Fig. 46; Fig. 47] These moments captured by Abbas's lens signal the underlying dislocations of Iran in the 1970s and offer insights into the events that followed.

ABOVE Fig. 46. ABBAS.
Car Assembly Plant, Tehran. 1977.
Gelatin silver print.
20 x 24 in. (50.8 x 61.2 cm).

BELOW Fig. 47. ABBAS.
Hairdressing Salon, Tehran. 1977.
Gelatin silver print.
20 x 24 in. (50.8 x 61.2 cm).

When the Revolution began, Abbas took his camera to the streets. "The revolution started with small streams and suddenly the small streams came together and it became like a huge river. I went to the streets of Tehran and started photographing … There was something almost every day. Then, there were some quiet moments. After a major riot, it was like the whole city had a hangover, and then things got quiet. After a few days, it would start again."[2]

Abbas's photographs were published in leading magazines, and they provided a window onto the revolution's quotidian manifestations.[3] During key periods, the imposition of martial law or violent rioting stilled the regular flow of people and traffic in Tehran's streets. Photojournalists' images acquired documentary significance for those Iranians shuttered in their homes and for those living in distant places. In his seminal essay, *Camera Lucida*, Roland Barthes pointed to the "evidential force" of photographs.[4] Indeed, during the Revolution, photographs could confirm or dispute official news on the state-controlled media or unofficial gossip of the rumor mills. As the artist and critic Victor Burgin argued, "The photojournalistic 'snap' has an authority which other forms of picture-making lack; it presents itself as factual evidence of an actual state of affairs."[5] Throughout the Revolution, documentary photographs, with their claims of inherent truthfulness and ability to construct legible signs out of destabilizing moments, became significant as evidentiary *and* interpretive representations of events. In an essay on documentary photography, Graham Clarke explained the duality of this genre: "It seems the most obvious of categories, and is used precisely *as* evidence of what occurred … Equally, documentary photography shows the camera at its most potent and radical. The very subject-matter of the documentary photograph is an index of the contentious and problematic as well as emotional and harrowing experiences: poverty, social and political injustice, war, crime, deprivation, disaster, and suffering are all difficult areas to photograph and all potentially problematic in the way a photographer will approach their meanings in terms of his or her own assumptions."[6]

Even for those who actually participated in the Revolution, the photographic representation of events was significant. They were mindful of the role of the camera in constructing and transmitting revolutionary meaning. Some of Abbas's photographs were cropped and reproduced in revolutionary posters; these revolutionary artists thus seized the photographic content with its evidential force to reproduce in their own visual imagery. One revolutionary poster illustrates the awareness among revolutionaries of the interpretive

potential of photojournalism. It depicts a journalist; the lens of his camera contains a cropped photograph of revolutionary demonstrations. The poster's caption reads: "The humanity stresses to any responsible journalist to refelect [sic] the nature of Iran [sic] Islamic revolution around the world as it is."[7]

Throughout the Revolution, Abbas spent much of his days in the streets; when he heard news of an event in another part of the city, he would hitch a ride on the back of a motorbike. "Even when you are following events, you have to be conscious of the process, of what is happening. This is difficult, because it means you have to anticipate what is going to happen. You are aware that all these events you are witnessing are part of something more important. You put the pictures together at the end (maybe as a book, as an exhibition) so this has to be in the back of your mind all the time. You are witnessing events that are leading to a bigger event, the revolution. Your photography follows the same process. You are photographing, taking pictures one by one, but you are thinking of something bigger at the end. In my case, I knew I would do a book on Iran."

In a number of Abbas's photographs of the Revolution, the viewer stands in front of and close to the action, as if they were a part of the scene. The composition of these photographs situate the viewer directly before the picture. This gaze may reflect Abbas's own position. He was in the streets, a part of the Revolution. In one respect, his photographs are reactive, following events. But he had become a part of the crowds he photographed, tapping into their movements, anticipating events. He was invested in understanding the implications of what was unfolding around him. "For instance this picture of a woman standing alone with a row of men. That was one of the earlier mass demonstrations – ashura. The pretext for the occasion was religious. In fact this picture is not a fair representation of that day. There were millions of people in the street for the first time, and they were all happy to be together. Suddenly posters with pictures of Mossadeq[8] came up in the crowd. I saw this woman, standing alone behind a row of men, and I thought her position said something about the role of women in this revolution. In a way, in this picture, I anticipated what would become of women after the revolution." [Fig. 48]

The photographic pose that most frequently captured the women participating in the Revolution depicted them as "the veiled women" who eschewed "Westernization" and stood alongside their brothers in the streets. These image-women too often became reduced to symbols. "I remember in the early days when the revolution happened," he explains, "we were always trying to get either a veil or a mullah's turban, because it said Iran right away.

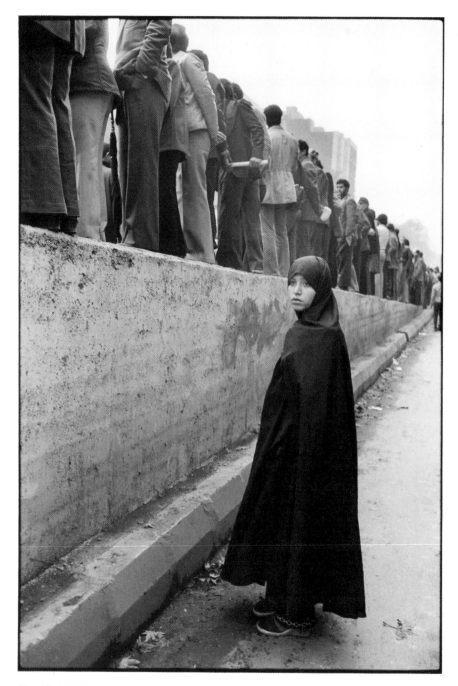

Fig. 48. ABBAS.
Young Woman at Anti-Shah Demonstration, Tehran. 1978.
Gelatin silver print.
24 x 20 in. (61.2 x 50.8 cm).

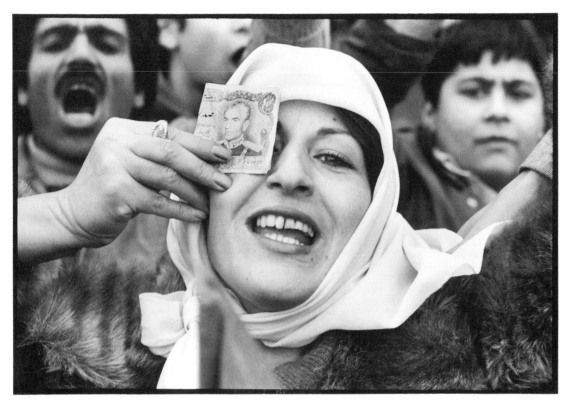

Fig. 49. ABBAS.
Woman at Pro-Shah Demonstration, Tehran. 1979.
Gelatin silver print.
20 x 24 in. (50.8 x 61.2 cm).

And many photographers were doing that. Then I got tired of that and decided I couldn't just work with symbols." Indeed, a number of Abbas's photographs tell a more nuanced gender story. Sometimes, the story is told in indirect ways, and the secondary, out-of-focus background images provide important details. Other times, a simple but stark image in the foreground spells it all out. A smiling woman in one photograph holds a folded rial bill in front of her eye, proudly displaying the Shah's image on the currency. Your eyes turn to her fur coat and the diamonds in her ring. The arm of a man outside the frame pushes down menacingly on her shoulder. Behind her, a man raises his fist in anger, his mouth open in a silent scream. [Fig. 49]

A petite elderly woman glances emotionless into the camera as she runs down a street, soaked with mud and rain. A young man holding an iron rod in his hand pushes her along; another pulls at her jacket sleeve. An angry

man to her right yells as he punches her in the face. The mob has determined she is a collaborator; her fate appears ominous. [Fig. 50] "It was my country, my people, my revolution, but this didn't mean that I should lose my critical sense. That is why I took pictures like the one of the old woman being lynched by the crowd. Not only did I take these photographs, I showed them. Because the germ of what happened afterwards was already there in the faces of the people you see in the photographs – this fanaticism, this anti-woman – it's all there. Of course, my duty was to the revolution, but also to my trade, to my craft."

Abbas's photographs seize moments that can stand alone as discrete images, but taken together in sequential order, they reveal the changing rhythm of the Revolution. In a 1978 photograph, a mixed group of seeming-ly unlinked men gather in an arch around the camera as they stoke a bonfire

Fig. 50. ABBAS.
Supporter of the Shah is Lynched, Tehran. 1979.
Gelatin silver print.
20 x 24 in. (50.8 x 61.2 cm).

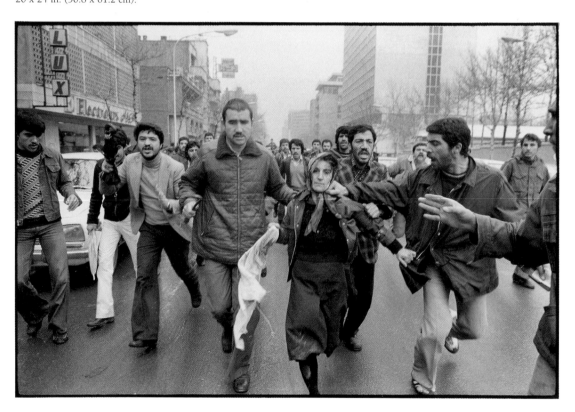

in which a photograph of the Shah burns. A 1979 photograph shows a sea of veiled women, arms raised to the sky as they await Khomeini's return. By the fall of 1979, the marchers wear army fatigues and carry weapons as they stage a demonstration outside the U.S. embassy where American diplomats have been taken hostage. The demonstrators raise fists as they chant slogans. Behind them, a printed banner displays their pro-democratic, anti-imperialist message. Perched above the scene is an out-of-focus image, on a poster, of the silhouette of the Statue of Liberty. All these images mark a decided change, both in Abbas's photographic composition and in the content which Tehran's streets provide for his camera. Together, the photographs reveal a critical shift from spontaneous rioting to staged collective action. We see the transition from a popular revolutionary uprising to an increasingly Islamic movement. By 1980, the movement has been appropriated by the state. On the first anniversary of Khomeini's return to Tehran, a photograph shows the black waves of masses, a ubiquitous visual image that had become a compelling representation of the populist Khomeinism of the Islamic Republic of Iran. But Abbas's closer view of the crowd shows a chaotic mosh pit, a fainting boy is carried above the heads of the crowd, the hats of the uniformed guards glisten in the rain as they push along the edges of the crowd, an eerie steam rises from the crowd. The destruction of the iconic imagery of Pahlavi Iran gives way to the construction of a revolutionary pictorial language that consciously presents itself as a visual narrative. A closer look reveals a rupture in the hegemonic picture-narrative of the state—order gives way to chaos, celebration is mediated by force. [Fig. 51; Fig. 52; Fig. 53; Fig. 54]

Abbas's camera captures significant moments, but it is in a continuum of images that these moments acquire meaning. "There are really three high moments in photography for me. One is when I am shooting. You have to be aware of movement, of shadows. When I am photographing, I am not normal; I am in a state of grace. In the evenings when I finish, I am totally worn out emotionally. It's like coming back from the front lines of a war. The second moment is when you see your contact sheets. No other creator is so dependent on technology – something could go wrong with the camera, the film, the developing. You don't know what you have until you see the contact sheets, but then you not only see the moment you have captured but also the pattern. Then I start to edit, putting pictures together. That's the third moment, when I work out the sequence. That's when the writing happens; it's when my narrative takes shape. My photographs are important in a sequence; the meaning is in the sequencing."

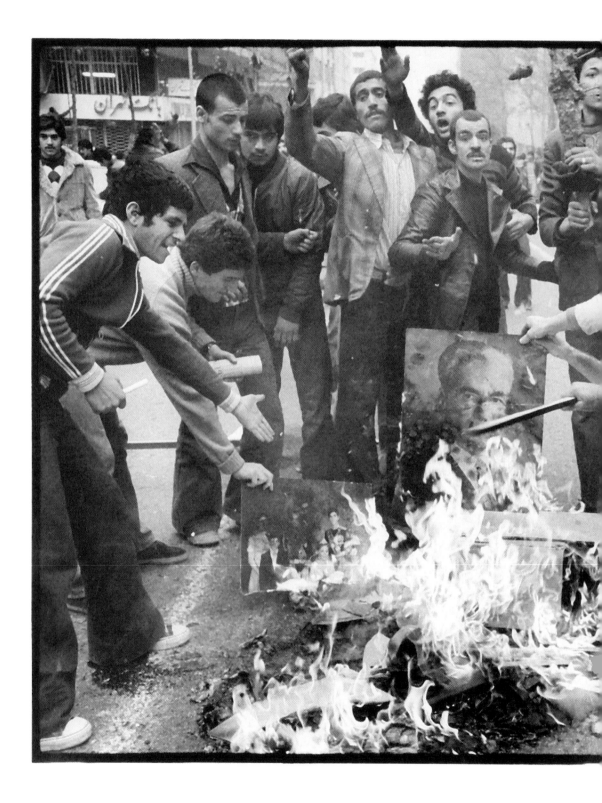

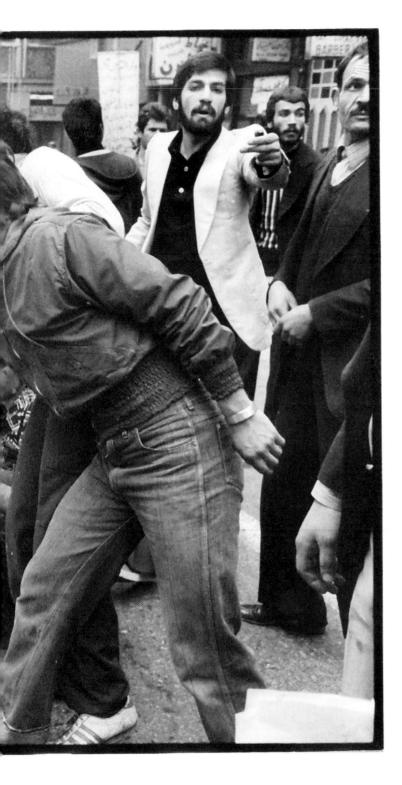

Fig. 51. ABBAS.
Men Burning a Portrait of the Shah, Tehran. 1978.
Gelatin silver print.
20 x 24 in. (50.8 x 61.2 cm).

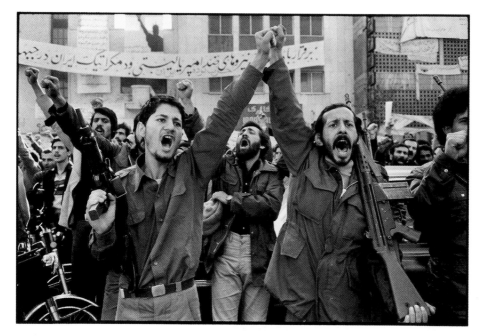

Fig. 52. ABBAS.
*Armed Militia Outside the US Embassy Where
Diplomats are Held Hostage,* Tehran.
December 1979.
Gelatin silver print.
20 x 24 in. (50.8 x 61.2 cm).

Fig. 53. ABBAS.
*Women Welcome the Ayatollah Khomeini
upon His Return from Exile,* Tehran. 1979.
Gelatin silver print. 20 x 24 in. (50.8 x 61.2 cm).

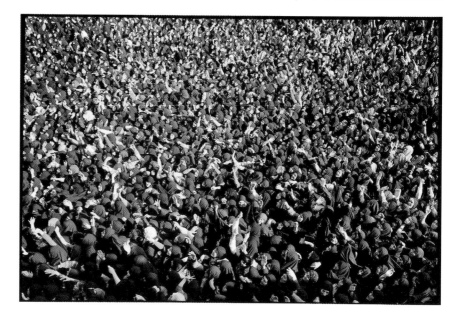

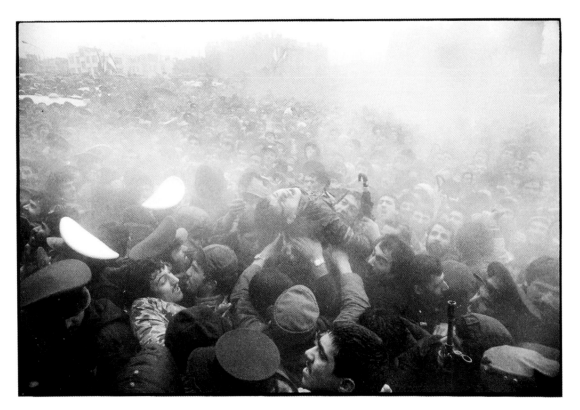

Fig. 54. ABBAS.
First Anniversary of the Revolution, Tehran. February 11, 1980.
Gelatin silver print.
20 x 24 in. (50.8 x 61.2 cm).

In other words, Abbas's photographs ultimately render moments into meanings. A foreboding Abbas triptych of the Shah's longtime prime minister, Abbas Hoveyda, spans nearly a decade and recounts the story of Iran in the 1970s. A photograph from 1971 shows Hoveyda at work. Dressed in a suit and tie, he sits and rests his arm on his ubiquitous cane. He is surrounded by technocrats and politicians, all standing around him, their arms demurely folded, leaning in to listen attentively to the discussion. Another photograph taken in the same year shows him resting in a wicker chair in the shade of the trees of his villa by the Caspian Sea. He is dressed casually in short sleeves and white shoes. He stares upwards at an unknown spot outside of the camera's frame as he puffs his pipe, another of his frequent props. His wife, Laila, sits nearby on a bench, a Pierre Cardin logo emblazoning her sweater; she too stares silently into the distance. A young man stands behind

Hoveyda, carrying a tray of tea and sugar cubes, his eyes in the appropriate downward gaze of a servant. When we see these early photographs of Hoveyda, knowing his impending fate, we can't help but search for revealing details that might reflect an underlying anxiety. Though both photographs show that he is a man of power, surrounded by subordinates at home and at work, he seems distracted and quietly disturbed. Knowing the content of the final photograph, these 1971 photographs resonate with a sense of darkness. The third photograph, taken in 1979, completes the narrative. Four men survey Prime Minister Hoveyda's corpse as it lies on a slab in the morgue. A young man in camouflage pants strikes a pose for the camera; lifting his gun, he smiles as he squeezes the trigger, perhaps reenacting the role of the executioner. [Fig. 55; Fig. 56; Fig. 57]

This photograph may well be one of the most enduring images of the Iranian Revolution. It was not, however, to stand alone. Another photograph by Abbas shows General Rahimi, the martial law commander of Tehran as he is presented to the press following his arrest. Rahimi sits at a table, raising his hands to God. He is surrounded by a group of revolutionary men; some lean

Fig. 55. ABBAS.
Prime Minister Hoveyda, Electoral Campaign, Yazd. 1971.
Gelatin silver print.
20 x 24 in. (50.8 x 61.2 cm).

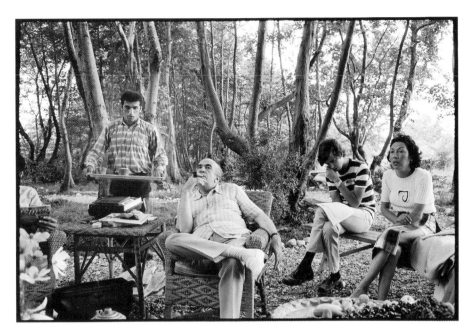

ABOVE Fig. 56. ABBAS.
*Prime Minister Hoveyda and his Wife
Leyla in their Summer Home.* 1971.
Gelatin silver print.
20 x 24 in. (50.8 x 61.2 cm).

BELOW Fig. 57. ABBAS.
*The Body of Prime Minister Hoveyda at
the Morgue,* Tehran. 1979.
Gelatin silver print.
20 x 24 in. (50.8 x 61.2 cm).

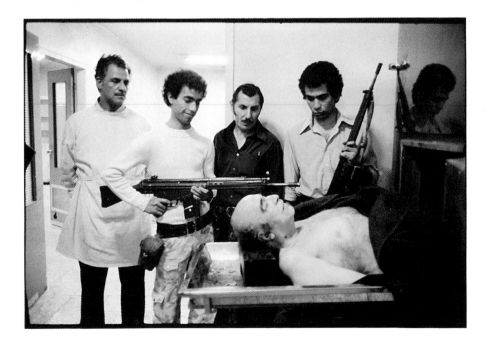

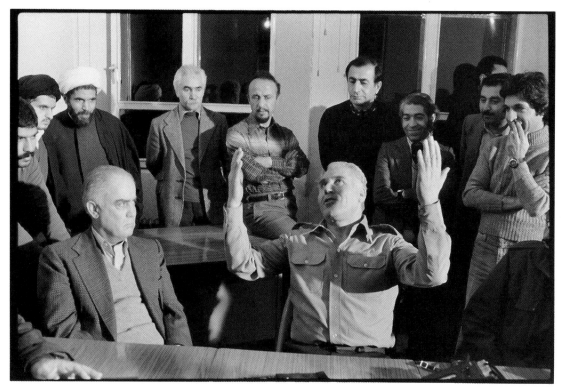

Fig. 58. ABBAS.
Taken prisoner, General Rahimi says he is in the "Hands of God.". 1979.
Gelatin silver print.
20 x 24 in. (50.8 x 61.2 cm).

in to hear his prayers, others smile at the sight. In another photograph, we see the man's corpse, along with the bodies of three other generals, in the morgue. [Fig. 58; Fig. 59] These photographs bear witness; they speak in the starkest terms of betrayal, of hasty retribution, of justice gone awry, of abusive power. They signal a violent turn in the Revolution and mark a profound shift in Abbas's photographic relationship to the Revolution. After the generals were summarily executed, Abbas wrote, "At that moment, I knew that this revolution would no longer be mine … I chose to continue with my obstinate testimony rather than withdraw, angry and scornful."[9]

Abbas's official role in the 1979 Revolution was as a photojournalist, but his gaze was a critical one. He did not stand apart from the scenario, laying claims to objectivity. "My photography is not anonymous photography. When I take photographs, I have a point of view. I have a culture; I have a

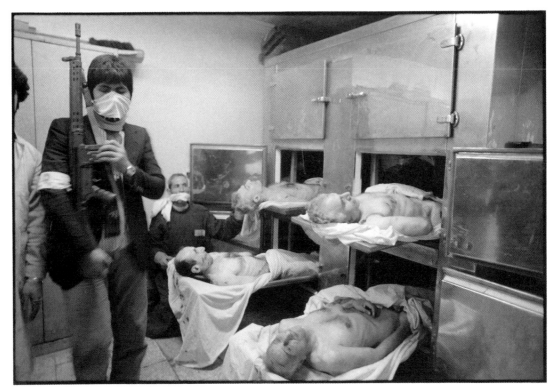

Fig. 59. ABBAS.
General Rahimi (top right) and Three Generals Executed After a Secret Trial, Tehran. February 15, 1979.
Gelatin silver print.
20 x 24 in. (50.8 x 61.2 cm).

background. I hope this comes through in my photographs." This point of view translates into a photographic stance that is apparent in Abbas's revolutionary photographs, reflecting not only his relationship to Iran but also his creative impulse and influences. Henri Cartier-Bresson, one of the founders of Magnum, has clearly been an influence on Abbas. One of the few photographs displayed in his home in Montmartre is Cartier-Bresson's picture of Iranian wrestlers. "A photographer totally immersed in his subject in a way becomes a medium himself. He captures forces which he is not aware of; he does it unconsciously … I looked at the work of Cartier-Bresson, and I realized that he was a medium as well. He was only in Iran for three weeks, but his vision was so acute that he was seeing things that only someone with a very long experience of Iran would have known. His photograph of the wrestlers really said something about Iran, the strength of Iran, the tradition

of Iran. That's when I started formulating this idea of a photographer becoming a medium: you function as a creator on an unconscious level."

The quietly disturbing way that Abbas captured the violence of the Iranian Revolution echoes one of the first major projects Henri Cartier-Bresson undertook soon after Magnum was founded. Anticipating the end of the European colonies, Cartier-Bresson chose Asia as his territory. He arrived in India a few weeks after Independence and developed a relationship with those close to Gandhi. On January 29, 1947, he photographed Gandhi at the Birla House. On January 30, Cartier-Bresson interviewed him; later that day, Gandhi was assassinated. Upon hearing the news of the shooting, he returned to the Birla House and eventually photographed nearly every aspect of the funeral. A series of images of Gandhi's funeral pyre that appeared in *Life* testify to Cartier-Bresson's photographic stance: as a quiet and subtle intruder, as a witness. Managing to get through massive crowds, Cartier-Bresson positioned himself at the front of the pyre. The ghee poured on the sandalwood, the body covered with flowers, the deep sorrow etched in the faces of the mourners offered an intimate, personal gaze into this public event of enormous historic significance.[10]

One of Abbas's photographs of the Iranian Revolution depicts a funeral pyre of sorts. It is a difficult image, showing the brutality of the Tehran streets in 1979. Fire had been set to a building presumed to be a brothel. When Abbas came across a demonstration, he saw the crowd carrying the charred body of a woman, presumed to have been a prostitute. "This photograph happened so quickly. I was on the grounds of the university, and I saw a crowd. I lifted my camera. I wasn't conscious of it. It was afterwards when I saw it on my contact sheets that it became significant, not when I was photographing it. It was too fast. Then I realized what I had done. Mind you, if the caption did not say it was the body of a presumed prostitute, maybe it would have a different meaning to you. If the caption didn't say anything, would it mean the same thing to you?"

Abbas's larger collection of photographs include many depictions of violence—the troubles in Northern Ireland, the occupation in Gaza, the war in Sarajevo. But his photographs of the violence of revolutionary Iran are markedly different. Their immediacy, their texture and tonality sets them apart from his other photographs. "In Iran, it was out in the open. The violence in those pictures is open violence, an exploding violence. I am too close to the thing."

This experience of photographing an exploding violence to which he was so close continued to affect Abbas even after he left Iran in 1980. He decided to travel to Mexico, where he stayed for a long period, taking photographs and writing about his recent experiences. In his Mexican diaries, Abbas wrote that he relived the violence and disappointments of the Iranian Revolution. "I had nightmares about Iran. When you are following an event that is violent, each photographer has his own recipe. Mine is to put an emotional curtain between what is happening and myself, so I can function. What I feel, I put it inside. This feeling becomes like a time bomb. It's there and when you least expect it, it explodes. That's why I tend to have nightmares after the event. That was one aspect of Iran's effect on me."

Abbas realized that the implications of the Islamic Revolution were going to extend beyond Iran's borders. He wanted to photograph this process, "but emotionally, I wasn't ready. I had invested too much and the revolution had somehow disappointed me. I wasn't part of it anymore. Also, I realized I didn't have the right tools." His Mexican pictures represent a search for a new photographic language that resulted in a transition to long-term projects. "I realized that if you want to do something more in depth on Islam, you have to be a writer – not a journalist, but a writer. The rhythm and the thinking is different. During the Mexico project, I acquired the tools to photograph not only the event itself, but the surroundings, the context."

One of these tools was a more complex understanding of the relationship between writing and photography, which for Abbas became increasingly integrated processes. W.J.T. Mitchell, an innovative critic, has argued, "The relation of photography and language is a principal site of struggle for value and power in contemporary representations of reality; it is the place where images and words find and lose their conscious, their aesthetic and ethical identity."[11] Newsphotographers encapsulate an event with a single image, relying heavily on the caption to define the significance of the content in order to elicit cognitive responses in the viewer. Abbas is mindful of the interpretive capacity of the caption. When we discussed his picture of the burned prostitute, he was clear that the power of that photograph lay as much in the caption as in the image itself. Nevertheless, in Abbas's photography, the question of writing and photography is not simply a question of the relationship between the picture and the caption. Abbas is a copious diarist, writing in French in a small, even script, with the occasional digression into Persian, English or Spanish. Since the 1979 Revolution, his books include selections from his diaries, integrating his photographs with his

thoughts on the subject, place or event; his general philosophical views; or descriptions of his photographic tasks. His books on Mexico and Islam include reflections on his experience photographing the Iranian Revolution. Like his photography, Abbas's diaries undergo an editing process that frames them into the subnarrative of his photography books. He understands that his photographs are open to multiple interpretations, but his writing lets the viewer know his own position—ethically, aesthetically, and intellectually—vis-à-vis his subject. For Abbas, writing and photographing are not disparate acts but part of the same process: "Writing a memoir and taking a photograph are the same thing; you are showing what you have seen." In his work, words and images are not discrete media. In a sense, his work reflects Walter Benjamin's notion that "photography turns all life's relationships into literature."[12]

Another impact of 1979 on Abbas was a shift in his relationship to traveling. The shorter visits of photojournalism gave way to extensive journeys over several years. And for many years, Abbas was no longer welcome in his home country. In 1980, the publication of his book, *La Révolution Confisquée,* rendered Abbas "a camera *non-grata*" in Iran.[13] This closure of Iran to him made Abbas an exile, of sorts, and the sense of place and rootedness, the notion of travel and return, became salient features of his work. Towards the end of Abbas's stay in Mexico, a friend gave him a handwritten copy of Attar's *The Conference of the Birds*. In his allegorical Sufi poem, Attar tells the story of the world's birds gathering together to seek a king. The hoopoe serves as the guide in the birds' journey to find their king, the Simurgh:

> I know our king – but how can I alone
> Endure the journey to His distant throne?
> Join me, and when at last we end our quest
> Our king will greet you as His honoured guest.
> … Do not imagine that the Way is short;
> Vast seas and deserts lie before His court.
> Consider carefully before you start;
> The journey asks of you a lion's heart.
> The road is long, the sea is deep – one flies
> First buffeted by joy and then by sighs;
> If you desire this quest, give up your soul
> And make our sovereign's court your only goal.[14]

At the end of the long journey, the thirty birds (*si-murgh* in Persian) realize that the sovereign that they seek, the Simurgh, is indeed themselves. Reading Attar's poem was revealing to Abbas: "The story of the Simurgh shows that you can not escape who you are; you always return to what you are. That's when I said I am ready for this Islam project. It was a small sign."

The writer Carlos Fuentes has described Abbas's photographs as "immortal gestures saved from the riptide of history that surrounds and drags us all down."[15] In 1979, Abbas's lens captured the immediacy of the Revolution. With time, his photographs have become a historical archive of the period. "I am conscious of the historical aspect. That is the strength of photography. Some of these pictures have become icons of the revolution. People don't remember the event; they remember the photograph of the event. Your own memory tends to fade, but the picture is still alive, it's still there, you can still go back to it. The picture becomes the event itself."

Abbas's photographs of Iran have become the memory of the event. For Marcel Proust, photographs were instruments of memory; for Susan Sontag, they are "not so much an instrument of memory as an invention of it or a replacement."[16] The experience of exilic loss, which Abbas shares with so many other Iranians, affects the meaning the images acquire over time. His photographs capture not just a moment that has passed, but a place that has been fundamentally transformed. As Edward Said wrote of the exilic photographic experience in the Palestinian context, "Something has been lost. But the representation is all we have."[17] In a way, Abbas's photographs, which at the time of the Revolution helped to disseminate information about the day-to-day unfolding of events, are now essentially "a materialized memory"[18] of that Revolution. They bring to mind Barthes's reflections on photography and the past: "Perhaps we have an invincible resistance to believing in the past, in History, except in the form of myth. The Photograph, for the first time, puts an end to this resistance: henceforth the past is as certain as the present, what we see on paper is as certain as what we touch."[19] When the Tehran Museum of Contemporary Art reopened following the Revolution, Abbas's revolutionary photographs were included in its earliest exhibitions.[20] As the revolutionary state memorialized itself, then, it turned to Abbas's imagery. Abbas's documentation of events helped, in a sense, in the production of the meaning of the Revolution—while it was happening and from a historical perspective. Ultimately, while Abbas was taking photographs in the streets of Tehran, he was writing a history of the Iranian Revolution of 1979.

NOTES

Haggai Ram and Lynn Gumpert were steady intellectual guides and companions throughout the time that I worked on this project. Abbas has been incredibly generous, sharing his insights, his history, and his tremendous photography archive with me. In a recent e-mail, he reminded me that we are all the *simurgh*, but my time with him has taught me how crucial and invigorating the journey itself can be. I would like to thank Robert McChesney, Richard Tapper, Ziba Mir-Hosseini, William Carrick, and Laila Danesh for commenting on drafts of this essay.

1 Abbas attended university in England and eventually moved to Paris. Earning a growing reputation as a world-class photojournalist, he joined Magnum in 1981, becoming a member in 1985. Abbas served as the President of Magnum from 1998 to 2001. Magnum was founded in 1947 by the photographers Robert Capa, Henri Cartier-Bresson, George Rodger, and Chim Seymour as a response to World War II. According to Fred Ritchin, "The world's most prestigious photographic agency was formed by four photographers who had been very much scarred by that conflict and were motivated both by a sense of relief that the world had somehow survived and the curiosity to see what was still there." Graham Clark explains the Magnum approach:

"Magnum is very much international in its concerns and styles, and has produced some of the definitive images of the last fifty years. But it is also eclectic and lays stress on individual approaches and philosophies as part of its 'documentary' approach." See Fred Ritchin, "Seeing the World Differently," in *Magnum Photos* (Paris: Editions Nathan, 1997), p. 1; Graham Clarke, *The Photograph* (Oxford: Oxford University Press, 1997), p. 156.

2 Unless otherwise noted, all quotations by Abbas are from an interview with the author in Paris, March 6, 2001.

3 Abbas's photographs have been published in leading magazines and newspapers including *Time, Newsweek, Paris-Match, L'Express, The Sunday Times, The Independent, El Pais, Stern*, and *Spiegel*. His photographs have been exhibited in France, England, Spain, Iran, Mexico, and the United States. His photography books include *La Révolution Confisquée* (Paris: Clétrat, 1980), *Return to Mexico: Journeys Beyond the Mask* (New York: W. W. Norton and Co., 1992), *Allah O Akbar, A Journey Through Militant Islam* (London: Phaidon, 1994), and *Faces of Christianity, A Photographic Journey* (New York: Harry N. Abrams, 2000).

4 Roland Barthes, *Camera Lucida, Reflections on Photography*, trans. Richard Howard (New York: Hill and Wang, 2000; originally published in 1980), p. 89.

5 Victor Burgin, "Art, Common Sense, and Photography," in *Visual Culture: The Reader*, ed. Jessica Evans and Stuart Hall (London: Sage, 1999), p. 44.

6 Clarke, p. 145.

7 Revolutionary poster, Stanford University Library, Hoover Institution Collection, IR51. I would like to thank Edward Jajko for his assistance and insights on Iranian revolutionary posters, which he offered during a visit to the Hoover Institution in September 2001.

8 Dr. Mohammed Mossadeq, a leader of the National Front Party, was the prime minister of Iran who worked to nationalize the oil industry. He was overthrown in 1953 with the assistance of the CIA and the British SIS. Documents relating to the 1953 coup were released in 2000 and can be seen at <http://www.nytimes.com/library/world/mideast/041600iran-cia-index.html>. During the 1979 Revolution, Mossadeq came to symbolize U.S. interventionist policy in the Cold War era and Iranian democratic aspirations. See James A. Bill and William Roger Louis, eds., *Musaddiq, Iranian Nationalism, and Oil* (Austin: University of Texas Press, 1988) and Homa Katouzian, *Musaddiq and the Struggle for Power in Iran* (London: I. B. Tauris, 1999).

9 Abbas, *Allah O Akbar*, p. 17.

10 This description of Cartier-Bresson's coverage of Gandhi's funeral is based on a study by Claude Cookman that compares

the photographic approaches of Bourke-White and Cartier-Bresson. See Claude Cookman, "Margaret Bourke-White and Henri Cartier-Bresson: Gandhi's Funeral," *History of Photography* 22, no. 2 (Summer 1998): 199–209. Interestingly, in an interview, Abbas remarked on this topic: "For instance Henri Cartier-Bresson could cover the aftermath of Gandhi's assassination because he took his pictures discreetly through a window, while another photographer had her films confiscated because she used a flash." See Abbas's interview with Yohei Kusangi on June 7, 2000, at <http://www.sputnik.ac>.

11 W.J.T. Mitchell, "The Photographic Essay: Four Case Studies," in *Picture Theory* (Chicago: University of Chicago Press, 1994), p. 281.

12 Walter Benjamin, "A Small History of Photography," in *One Way Street and Other Writings*, trans. E. Jephcott and K. Shorter (London: New Left Review Editions, 1979), p. 256.

13 Abbas has been returning regularly to Iran since 1997.

14 Farid Ud-Din Attar, *The Conference of the Birds*, trans. with an introduction by Afkham Darbandi and Dick Davis (London: Penguin Books, 1984), pp. 33–34.

15 Carlos Fuentes, introduction to Abbas, *Return to Mexico*, p. 10.

16 Susan Sontag, *On Photography* (New York: Farrar, Straus and Giroux, 1977), p. 165.

17 Edward Said and Jean Mohr, *After the Last Sky* (London: Pantheon, 1986), p. 84.

18 Mitchell, p. 289.

19 Barthes, pp. 87–88.

20 Sarah McFadden, "The Museum and the Revolution," in *Art in America* 69, no. 8 (October 1981): 15.

THE ART OF REVOLUTION
AND WAR:
THE ROLE OF THE GRAPHIC
ARTS IN IRAN

by Peter Chelkowski

THE GROWTH OF THE GRAPHIC ARTS in Iran in the 1960s and 1970s was directly connected to the process of modernization. As Iran became more industrialized and assumed an increasingly significant presence on the world stage, graphic images played an essential role in proclaiming the country's commercial, cultural, and political aspirations. However, despite the strong trend towards modernity and the fact that a number of the leading Iranian artists were trained in Western academies and ateliers, the popular beliefs and rituals of the Shiite Muslim faith provided an important source of imagery for the graphic arts.

At the time of the Islamic Revolution of 1979, a large percentage of the Iranian population was still functionally illiterate. Yet, most Iranians were very attuned to a wide range of mental and pictorial images going back hundreds of years. The Islamic Revolution revitalized and transformed these rituals and images, and put them to immediate political use. By the early 1980s, the Islamic Republic of Iran was in full semiotic control of the representation of itself, and serves as a dramatic example of how collectively held symbols—appearing in murals, graffiti, postage stamps, banknotes, posters, and primary-school textbook illustrations—were used to mobilize a people.[1] Even in a fully literate society, the production of ideological and political propaganda relies on a minimal use of words and the maximum impact of strong

graphic images. Effectively transmitting far-reaching political and religious messages to a large number of people requires an extremely simple yet sophisticated semiotic machinery. A graphic image could be appropriated at any time by any governmental or non-governmental body for use in a variety of media. For example, a design for a poster could be reduced in size to appear on a postage stamp, postcard, banknote, school textbook illustration; or it could be enlarged for a billboard or mural.

In the 1960s, Shiite themes figured prominently in narrative *pardeh* paintings, a genre that dates back to the late Safavid period (1501–1736), and served either secular or religious aims. *Pardeh* painting is sometimes called *shama'il*; the related storytelling, or performative component, is known as *pardehkhani* or *shama'ilgardani*. Essential to this tradition are large oil paintings on canvas, often measuring about five by twelve feet. Religious *pardeh* paintings and performances are devoted to the Karbala tragedy, based on a battle in 680 A.D. when Hossein, the beloved grandson of the prophet Mohammad, was brutally slain along with the other male members of this family and his close companions. The battle is depicted in great detail on the canvas with the protagonists of the tragedy appearing in multiple guises and various situations, thus endowing the painted story with dynamic movement. The performer, having unfolded a huge canvas on the wall or stretched it between two poles, begins acting the story to the entranced audience which sits in a semicircle in front of him.[2]

Pardeh is popularly known as "coffee-house painting," since Iranian coffee houses also served as artists' ateliers very much like the cafés where French writers often worked.[3] Although two great masters of this genre, Mohammad Modabber and Hossein Qular Aqassi, died about a decade before the Revolution, *pardeh* influence on revolutionary art is clearly seen in a postcard reproducing a poster by Hassan Ismailzadeh that depicts the downfall of the Shah Mohammad Reza Pahlavi. [Fig. 60] In it, vignettes of the revolutionary struggle take place against a map of Iran, recalling coffee-house paintings with their multiple scenes of dramatic events unfolding over time. Here, the main characters of the *pardeh* model—the gallant Hossein and the unhorsed enemy—are replaced by the victorious Ayatollah Khomeini chasing out the vanquished Shah. Behind Khomeini, there is an image of the Eiffel Tower, which refers to the long years he spent in exile in Paris. In his right hand the Ayatollah holds aloft the Koran. In the background, a billowing green flag inscribed with the words "Islamic Republic" and the Muslim profession of faith, "There is no god but Allah," confirm that this Revolution

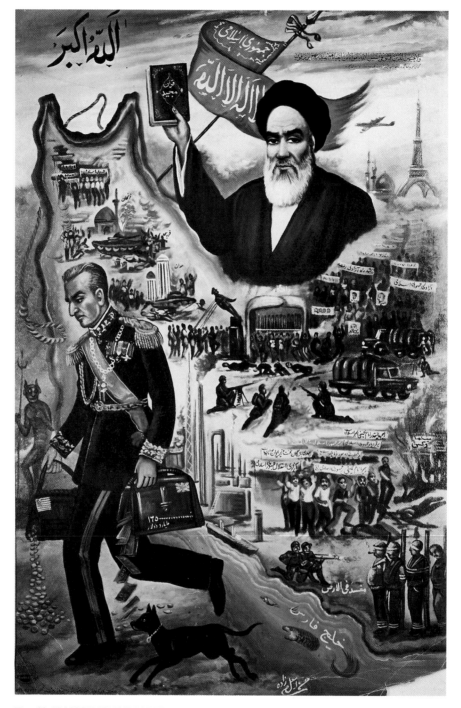

Fig. 60. HASSAN ISMAILZADEH.
Poster depicting the Shah's downfall. 1979.

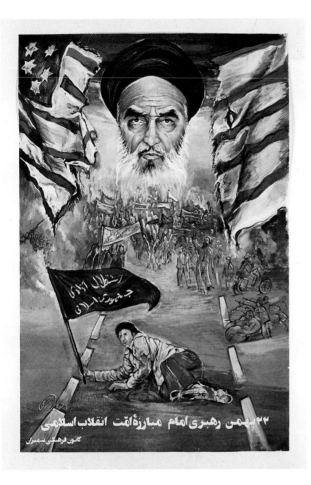

Fig. 61. A. RAZAVI.
Poster commemorating the establishment of the Islamic Republic, commissioned by the Shemiran Cultural Assembly. c. 1979.

was Islamic. Attired in full imperial regalia, the Shah makes his escape accompanied by a black dog and a red devil, just barely evading a noose. In both hands he holds briefcases emblazoned with American and British flags and stuffed with gold coins and banknotes which spill out onto the ground at his feet. Unlike *pardeh* paintings, however, where the narrative unfolds from left to right, in this revolutionary poster the action moves from right to left.

Another postcard of a poster by A. Razavi, which was commissioned by the Shemiran Cultural Assembly, also clearly evokes the tradition of coffee-house paintings. [Fig. 61] It depicts the proclamation of the establishment of the Islamic Republic on the twenty-second day of the month of Bahman. Again the main protagonist is the Ayatollah Khomeini, whose head hovers above the crowd and is visible through a torn curtain made of the American

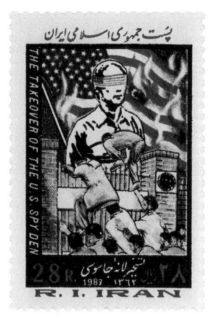

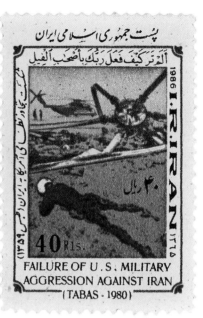

Fig. 62. Postage stamp inscribed "The Takeover of the U.S. Spy Den," commemorating the seizure of the U.S. Embassy, Tehran. 1983.
1 x 1 ½ in. (2.5 x 3.8 cm).

Fig. 63. Postage stamp inscribed "Failure of U.S. Military Aggression Against Iran," commemorating the failed U.S. attempt to rescue hostages. 1986.
1 x 1 ½ in. (2.5 x 3.8 cm).

flag. A bleeding revolutionary plants a banner bearing the inscription "Independence, Freedom, the Islamic Republic."

Political events continued to provide much fodder for the graphic arts of the revolution. In 1979, when the Shah arrived in New York City for cancer treatment, relations between the United States and the Islamic Republic deteriorated. With the hostage crisis, in which Iranian revolutionaries held American diplomats in captivity for 444 days, they were completely ruptured. Almost immediately, anti-American sentiments appeared in graphic designs, even down to postage stamps. A 28-rial Iranian stamp from this period depicts the hostage-takers scaling the main gates of the American Embassy in Tehran. [Fig. 62] A hostage, blindfolded with a strip torn from an American flag, is depicted before a larger Stars and Stripes in flames. The inscription, printed in English as well as Persian, reads "The takeover of the US spy den [sic]."

A 40-rial stamp refers to the failed rescue mission to free the hostages. [Fig. 63] By orders of U.S. President Jimmy Carter, American helicopters from an aircraft carrier stationed in the Arabian Sea flew to a staging base in the desert outside Tehran, where they were supposed to refuel. Upon encountering a strong dust storm, three out of the eight helicopters retreated. The remaining helicopters arrived too late. The mission was aborted and, in the process, a helicopter collided with a refueling tanker plane, killing several American servicemen. The postage stamp shows a fallen American soldier and wrecked aircraft; above is an inscription in Arabic of the first line of the "Elephant" chapter in the Koran. The verse, which reads, "Seest thou not how thy Lord dealt with the Companions of the Elephant?" refers to a battle that took place in the year of the Prophet Mohammad's birth. A certain Abraha, Governor of Yemen, intoxicated with power, led a large expedition, which included one or more elephants, against Mecca, intending to destroy the holy Muslim shrine, the Ka'ba. The Ka'ba's custodians offered no resistance as the enemy army was clearly too powerful. Instead, a miracle saved the day: a shower of stones, thrown by flocks of birds, it was believed, destroyed the invading army by causing skin pustules which spread like a plague. A better parallel to the unsuccessful American hostage rescue mission could not have been found. Posted to countries all over the world, this stamp image commemorating the American defeat was easily recognized. Only citizens of other Muslim states, however, would have understood the Koranic allusion.[4]

After the Shah's departure from Iran in January 1979, a unique period, lasting about a year and a half, witnessed a flowering of the arts. Representing a wide political spectrum from Nationalists to Communists, artists at this time worked in a number of different traditions including European Beaux-Arts, classical Persian methods, and Soviet-based Socialist Realism. One example of the Socialist Realist genre from this period is a postcard reproducing a straightforward poster celebrating the 11th day of the month of Ordibehesht (May 1), that is, International Workers' Day. [Fig. 64] In it, a close-up of two powerful arms hold aloft a blacksmith's hammer and wrench, which have metamorphosed into a bouquet of red flowers. It comes as a surprise that the Islamic Republic Party, a very conservative clerical political party, is the commissioning agency of this potent leftist message and is identified in the lower left corner.

This honeymoon of the politically progressive and fundamentalist religious groups was all too brief and Islamic ideologues quickly launched an all-out propaganda campaign to claim the Revolution for themselves. They

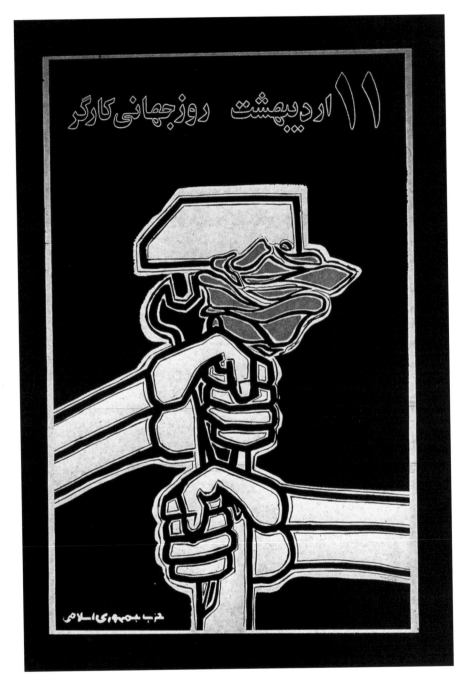

Fig. 64.
Poster commemorating International Workers' Day.
c. 1979–88.
24 x 16 in. (61 x 40.6 cm).

organized an army of artists who, via the graphic arts, strove to mobilize the general public and cripple potential rivals and opponents. As in pre-Revolutionary Iran, artists drew on both modernist and traditional Shiite or Islamic influences. One of a series of brightly colored silkscreened posters, commissioned by the newly formed Art Bureau of the Islamic Propagation Department, provides a striking example.[5] [Fig. 31] The artists, Ahmad Aqa Qolizadeh and Sedigheh Vosughi, were no doubt inspired by Andy Warhol's portraits of the Shah and the Empress which were hanging on the walls of the imperial palaces and the Tehran Museum of Contemporary Art. Like the famous American Pop artist, these Iranian graphic designers based their portraits on photographs of the subjects that were greatly simplified and set before an abstracted background of enlarged benday dots.

When Saddam Hussein invaded Iran in the Fall of 1980, the graphic arts of the Islamic Republic of Iran faced a new challenge: to rally the nation to the defense of the country and repel the aggressor. During the Pahlavi era, the graphic arts were employed to sell goods and services. Using techniques learned during the Revolution, Iranian graphic artists sought to inspire, mobilize, and commit the entire nation to action. Never in the history of propaganda have the graphic arts systematically played such an important role as they did in Iran in the years 1980–88. Organized into workshops in towns, villages, and even trenches, a veritable army of artists labored ceaselessly to produce art that would encourage and inspire soldiers and civilians alike. During this time, the high walls enclosing traditional dwellings in Iran provided an ideal surface for artists to display their graphic prowess and, at one point, it seemed as if not a single wall in Iran remained uncovered by murals, posters, and graffiti.

An obvious target at the time was Saddam Hussein, who was relentlessly demonized by Iranian artists. Taking a cue from the Allied propaganda of World War II, one image fuses the face of the Iraqi leader with that of Adolf Hitler, clearly identifying Saddam Hussein as a war criminal. [Fig. 65] During World War II, Iran maintained close ties with Germany. In an attempt to convince Iranians that Hitler and his associates were evil, Allied propaganda had employed characters from the *Shahnameh*, the national Iranian epic.[6] For example, in one propaganda piece, which was painted in a classical, Persian miniature style, the archvillain of the epic, King Zahhak resembles Hitler, while Zahhak's characteristic attribute—two serpents growing from his shoulders—appears with the heads of Benito Mussolini and Hideki Tojo.

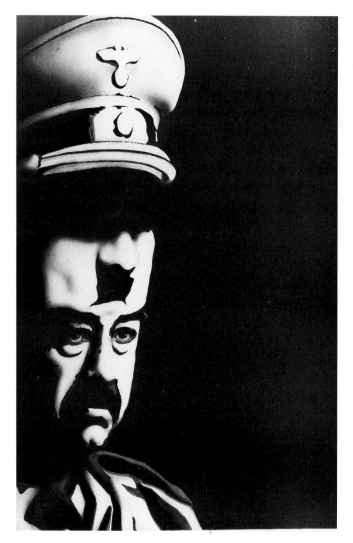

Fig. 65. MAJID GHADERI.
Postcard depicting a composite of Hitler and Saddam Hussein.
1983–85.

A postcard reproducing the central panel of an immense painted mural in the city of Gorgan expresses the apotheosis of the sacrifice, underlining the people's efforts during eight years of war. [Fig. 66] The battle was waged not only in the trenches at the front but also in the streets and alleys of Iranian towns and villages. Murals, posters, and other graphic arts were intended to maintain a positive spirit and ensure military preparedness.

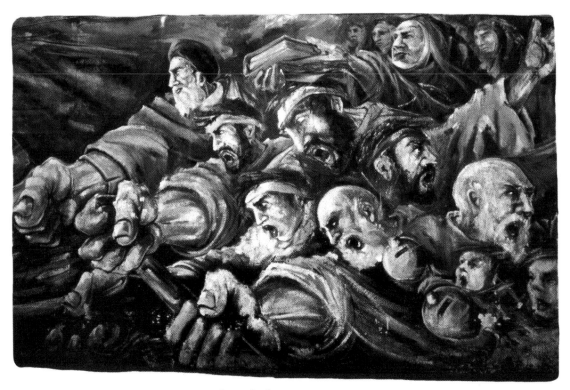

Fig. 66. Postcard reproducing the central panel of
a tripartite wall mural in Gorgan, Iran. c. 1980–85.

Inspired by such propaganda, teenagers joined their elders and went hand in
hand to the front in the ranks of the *basij* (mobilization) military units.

Iranian women, however, did not participate in the bloody combat
against the Iraqi invaders. Nonetheless, in graphic propaganda they are occa-
sionally depicted as combatants, with guns slung over their shoulders. For
example, in a 10-rial stamp issued to celebrate Woman's Day—which in the
Islamic Republic marks the birthday of Fatemeh Zahra, daughter of the
Prophet Mohammad and wife of Ali, the first Shiite Imam—we witness a
dynamic representation of the fighting woman. [Fig. 67] In it, a Zahra-like
woman wearing a blood-red scarf arises from a rally of women clad in black
chadors. Her hand held high in exhortation, she urges her sisters to act. Her
gesture echoes the finial in the form of an outspread hand atop an adjacent
white flag, representing the five holy personalities of Shiite Islam. A flurry of

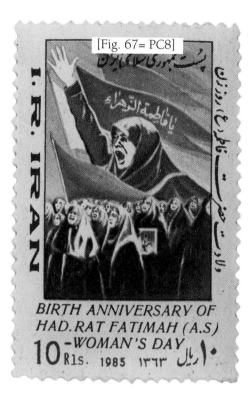

[Fig. 67= PC8]

Fig. 67. Postage stamp commemorating the birthday of Fatemeh Zahra. c. 1980–85. 1 x 1 ½ in. (2.5 x 3.8 cm).

Fig. 68. Postage stamp depicting a woman in hejab (Islamic dress). c. 1979–80. 1 ½ x 1 in. (3.8 x 2.5 cm).

billowing green flags flying over the heads of the crowd—one bearing the words "O Zahra!"—adds further dramatic impetus to the procession. A 20-rial stamp portrays the simplified head of a woman clad in a chador and carrying a gun slung over her shoulder. The inscription, "hejab," means a proper veiled attire for women. Her white face, surrounded by the black of the chador, functions here as a reversed pupil in the center of an eye—making visual the expression "in the eye of the beholder." [Fig. 68]

Of all the media employed as propaganda, currency stands out as one of the most powerful as it is, of necessity, constantly used by everyone in society regardless of gender, age, or social class. Exchanged by millions of hands, day and night, at home and abroad, it is scrutinized for its value and always close at hand. Tapping into a universal desire for money, the graphic designers and engravers of the Islamic Republic convey their message in clear, familiar, and easily comprehended images. The obverse face of a 10,000-rial banknote depicts an unending religious procession turned political march. [Fig. 69] Led by clerics, the marchers—who come from all strata of society—carry portraits of Ayatollah Khomeini and banners proclaiming

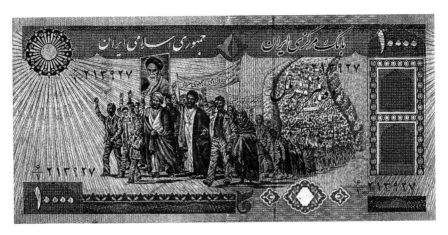

Fig. 69. 10,000-rial banknote depicting a Muharram procession. c. 1980–88.
3 x 6 ¼ in. (7.6 x 15.9 cm).

their allegiance to him. Taking part in one of the weekly demonstrations across Iran in support of the war effort against Iraq, these marchers move towards the warm rays of the sun, which symbolizes the coming victory.

Less than a year after the end of the devastating "Imposed War," Ayatollah Khomeini died. A postcard reproduces a painting, executed in classical Persian miniature style, that recounts his life and death. [Fig. 70] In it, we see him progress from youth to old age. At one point, he carries flags in the three symbolic colors of the Iranian nation: green for Paradise and the family of the Prophet; white for the burial shroud, and thus for martyrdom; and red for blood and sacrifice. In the painting, produced by the Art Bureau of the Islamic Propagation Organization, the Ayatollah comforts the wives, sisters, mothers, daughters, and small sons of the martyrs of the "Imposed War." In the center, the Ayatollah plays host to four representatives of the multi-ethnic Iranian nation. They are seated on a blue carpet woven with the figure of the legendary Bird of Birds, the *simurgh*, the icon of Iran's mythic past and mystical presence. In the upper right corner, the Ayatollah departs from earthly life, leaving his mantle behind. Here, past and present merge.

With the end of the "Imposed War" with Iraq and the death of Khomeini, the nation was exhausted. Since then, the production of art as propaganda has significantly diminished. On the untended walls of Iran, wartime murals and posters are fading away. Many have been whitewashed outright. In 1990, the former mayor of Tehran, Gholamhossein Karbaschi,

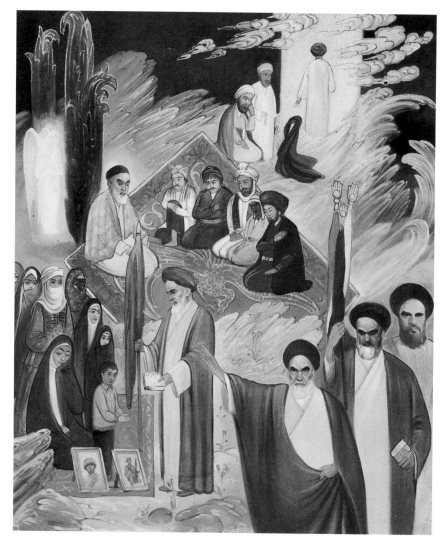

Fig. 70.
Reproduction of an oil painting depicting scenes from the life of Ayatollah
Khomeini, commissioned by the Art Bureau of the Islamic Propagation
Organization. 1988–89.
8 x 10 in. (20.3 x 25.4 cm).

ordered that the walls be cleaned; other towns and cities followed suit. With
this chapter behind them, Iranian graphic artists are now pursuing other
paths that we have yet to learn about.

NOTES

1 Peter Chelkowski and Hamid Dabashi, *Staging a Revolution: The Art of Persuasion in the Islamic Republic of Iran* (London: Booth-Clibborn Editions, 1999), p. 9.

2 Peter Chelkowski, "Narrative Painting and Painting Recitation in Qajar Iran," *Muqarnas* 6 (1989): 98–111.

3 For more examples of this genre, see *An Exhibition of Coffee House Paintings* (Tehran: Iran-America Society, 1967). See also Fereshteh Daftari, "Another Modernism: An Iranian Perspective," in this volume.

4 Peter Chelkowski, "Stamps of Blood," *American Philatelist,* June 1987, pp. 556–66.

5 Chelkowski and Dabashi, pp. 154–55.

6 Peter Chelkowski, "In Ritual and Revolution: The Image in Transformation of Iranian Culture," *Views* 10, no. 3 (Spring 1989): 7–11.

CONTRIBUTORS

SHIVA BALAGHI is Associate Director of the Hagop Kevorkian Center for Near Eastern Studies at New York University, where she teaches courses on cultural history and Women's Studies in the Middle East. She is currently completing a book on culture and nationalism in nineteenth-century Iran, which is based in part on her doctoral dissertation written at the University of Michigan. She has published several articles on Iranian cultural history and is the co-editor of *Reconstructing Gender in the Middle East* (Columbia University, 1994).

PETER CHELKOWSKI is Professor of Middle Eastern Studies at New York University, where he teaches courses on Islamic history and Iranian Studies. His most recent book is *Staging a Revolution: The Art of Persuasion in the Islamic Republic of Iran* (Booth-Clibborn, 1999) which he co-authored with Hamid Dabashi. His *Mirror of the Invisible World* (Metropolitan Museum of Art, 1975) received an award.

FERESHTEH DAFTARI is Assistant Curator in the Department of Painting and Sculpture at the Museum of Modern Art (MoMA) in New York. She has organized a number of exhibitions as part of the Project series at MoMA, including solo shows of artists Matthew McCaslin, Paul McCarthy, and Diana Thater. Her Ph.D. dissertation for Columbia University was published as *Influence of Persian Art on Gauguin, Matisse and Kandinsky* (Garland, 1991). She writes frequently on modern and contemporary Iranian art for *Tavoos*, a magazine published in Tehran.

LYNN GUMPERT is Director of the Grey Art Gallery at New York University. She was Senior Curator at the New Museum of Contemporary Art in New York and Adjunct Curator at the Museum of Contemporary Art where she researched contemporary Japanese art. She has also organized exhibitions in Europe and Japan, and has written on modern and contemporary art in Asia. Her monograph on the French artist Christian Boltanski was published by Flammarion in 1994.

HAGGAI RAM is Associate Professor of Middle East Studies at Ben-Gurion University of the Negev in Israel. He is currently completing a study of nationalism in post-revolutionary Iran. Ram is the author of *Myth and Mobilization in Revolutionary Iran* (American University Press, 1994) and has written numerous articles on Islam and Iran. He received his Ph.D. from New York University.

COLLECTION AND PHOTO CREDITS

Front cover illustration and Figs. 6, 11, 12, 32, 34, 36, 40, © 2002 Artists Rights Society (ARS), New York/ADAGP, Paris.

Back cover illustration and Figs. 8, 22, 24-26, Collection of Nicky Nodjoumi, New York.

Figs. 1-3, Courtesy of Annabelle Sreberny, Centre for Mass Communication Research, University of Leicester.

Figs. 4-7, 11-18, 20-21, 38, 42, Collection of Grey Art Gallery, New York University. Gift of Abby Weed Grey.

Fig. 9, Collection of Golestan Palace, Tehran.

Fig. 19, Collection of the artist, New York.

Fig. 23, 27-31, 43-45, 64, Collection of Hoover Institution Library and Archives, Stanford University.

Fig. 32, Collection of The Museum of Modern Art, New York. Philip Johnson Fund.

Fig. 33, Formerly Negarestan Museum.

Fig. 34, Private Collection.

Fig. 35, Collection of Museum of Islamic Arts, Tehran.

Fig. 36, Collection of Kamran Diba.

Fig. 37, Collection of Parviz Tanavoli.

Fig. 39, Collection of Walker Art Center, Minneapolis. Gift of the Ben and Abby Weed Grey Foundation, 1963.

Fig. 40, Formerly Centre International de Recherches Esthétiques, Turin.

Fig. 41, Collection of the artist, Paris.

Figs. 46–59, Courtesy of Magnum Photos, New York.

Figs. 60–61, Collection of Middle East Documentation Center, University of Chicago.

Figs. 62–63, 65–70, Private Collection.

Thanks to Frank Oudeman (Figs. 4-5, 7-8, 13-17, 21-22, 34-35, 42, 62-63, 67-69) and James Prince (Fig. 18) for photographing works from the Grey Collection.

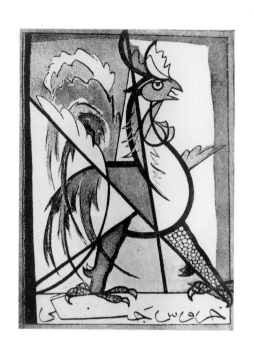
خروس جنگی